Bali Sketchbook

Dedication.

This book is for my children Stefan, Tania & Kristjan, who may one day return to Asia to discover "The Island of the Gods" for themselves.

Acknowledgements

My first visit to Bali was a revelation. And so were the people of Bali and some of the new friends I made who helped me to understand the island and its mysteries.

So my acknowledgements are many. But I am especially grateful for the encouragement from Made Wijaya who pointed out many architectural "gems", and for the help from Albert Beaucourt who devised many of my itineraries.

To Colin Gatenby for his kind hospitality at his Bedulu house and to Jayne Norris for overseeing a lot of my work with the eye of a professional artist.

And Diana Darling who introduced me, in detail, to "The Island of the Gods" and has written so interestingly of the island she clearly loves.

Finally to Tim Jaycock, my patient editor and Didier Millet, my friend and publisher who originally had the idea for the *Bali Sketchbook*.

Thank you to everyone.

I hope I have done Bali justice.

Artwork © Graham Byfield, 1998
Text © Diana Darling, 1998
Design and typographical arrangement
© Editions Didier Millet, 1998

First published 1998. Reprinted 1999, 2000, 2002, 2008, 2019

Published by Archipelago Press
an imprint of Editions Didier Millet,
78 Jalan Hitam Manis
Singapore 278488
www.edmbooks.com

Creative Director: Graham Byfield
Studio Manager: Tan Seok Lui
Production Manager: Annie Teo

Colour separation by
Colourscan Co. Pte. Ltd.
Printed in Malaysia by
TWP Sdn Bhd

ISBN 978-981-3018-59-4

Bali Sketchbook

Watercolours by Graham Byfield
Text by Diana Darling

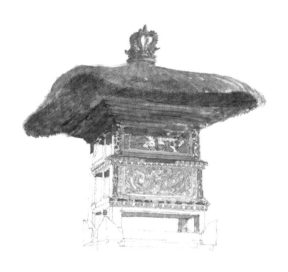

edm EDITIONS
DIDIER
MILLET

Contents

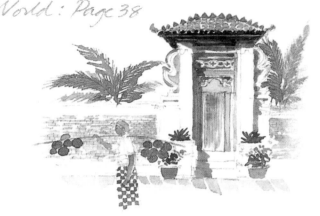

Introduction

This book records an English artist's discovery of Bali at the close of the 20th century – a more difficult adventure than you might think. Bali is a hard place to see freshly. It is so famous, has been so extensively photographed, painted, and promoted – has become so self-consciously exotic – that a first-time visitor gravitates naturally toward the official tourist images.

We wanted to avoid that. (It was my job to introduce Graham Byfield to Bali and to work with him on the general structure of the book.) Although we wanted to present images that would remind visitors of their stay in Bali, we didn't want to simply duplicate guidebook images in watercolour. Instead, Graham Byfield chose to concentrate on the things that attracted his artist's eye – that is, on architecture and the graphic rhythms in Bali's crowded visual landscape.

Still we needed an organizing concept that would present Bali in a whole way – and for that we turned to the well-known Balinese idea of the three-part nature of things. This idea is expressed in many ways: upper/middle/lower; gods/humans/demons; head/body/feet; temple/village/graveyard; and mountains/rice fields/sea.

This tripartite notion shows up in Bali's history as well as its cosmic geography.

The mountains are perceived as the realm of origins – probably because this is where irrigation water originates, in lakes and springs. It is also where Bali's earliest communities settled – probably because of the safety of mountain valleys, the availability of game and fresh water in the forests, and the primordial association of mountain tops with spiritual energy.

The broad central plains are fertile rice-growing lands, where villages and many tiny kingdoms grew up. Human society became ordered by a complex ritual culture. It was nourished by Hindu-Buddhist court arts from Java and flourished throughout the past millennium.

The sea is the place of endings and beginnings – where the ashes of the cremated dead are scattered, and from whence invaders arrive, establishing new ideas and technologies in the coastal towns.

All these ideas are encoded in Bali's architecture. From mountain temples to palaces, village streets and tourist hotels, basic forms are recapitu–lated like a musical theme – while the variations provide clues about the pressures of change.

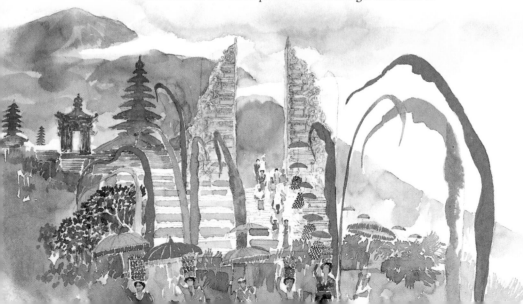

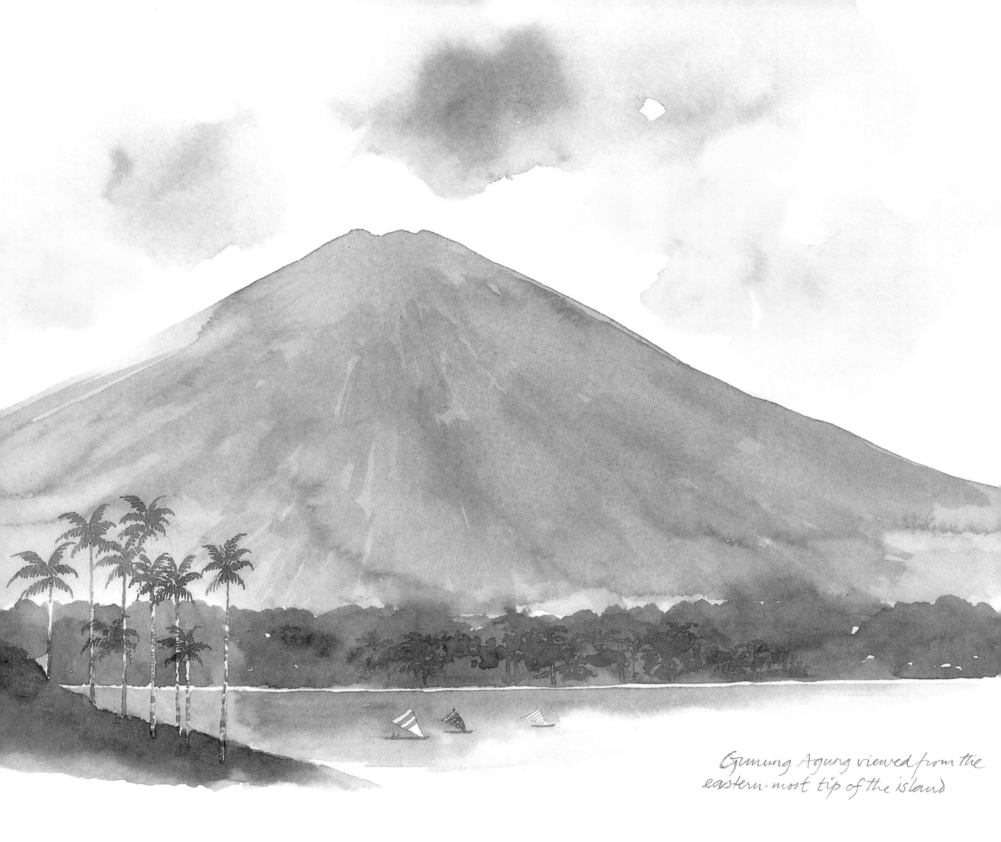

Gunung Agung viewed from the
eastern-most tip of the island

To the rice farmer, the mountain-to-sea symbolism is essentially about the flow of water – the most strategic factor in the growing of rice. The problems and solutions of rice-growing in Bali may be observed in the "engineered landscape" of its terraced rice fields.

The cultivation of paddy rice requires that the fields be flooded and dried at precise stages of the growing cycle. The paddy field works rather like a bathtub, in that water may be let in or out of the field at will, with a few chops of the farmer's hoe. But there remains the problem of the water supply.

Source water descends from the mountains, carving deep river gorges in the soft volcanic earth. The arable land is thus high above the rivers, and water must be diverted at the top of the water system. This is done through a series of channels, tunnels, aqueducts and weirs. The network extends to every individual paddy field, and it provides for drainage channels into the rivers which eventually empty into the sea.

Thus a farmer can flood his fields in the dry season and drain them in the rainy season; but he is not free to plant whenever he likes. Bali's supply of ground water is limited, so farmers must work out a planting schedule that staggers the use of water, and also takes into account the movement patterns of pests. With many thousands of individual farmers across a hilly terrain, the complexity of the problem is mind-boggling.

The ingenious solution – devised by the Balinese over a thousand years ago – is a network of water-sharing associations called *subak*, to which every rice farmer is obliged to belong. The *subak* is comprised of small local chapters (also called *subak*) whose members are responsible for the maintenance of the dams and channels from which their particular fields take water. Each subak chapter elects a representative (*pekaseh*). These pekaseh meet regularly to work out the planting schedule for their region, ever mindful of the requirements of those downstream.

The *subak* also look after the deities associated with rice farming. The lake goddess is honoured with an important temple at the lake itself (there are four lakes) and at temples throughout the irrigation system. The rice goddess is honoured in the fields at each stage of growth. At the downstream extremity of the system is another temple, which is a kind of transforming station for the impurities collected along the way. Thus the three-part scheme appears once again.

In the landscape of rice farming, the *subak* is a social organization that is collaborative and religious, hydraulic rather than hierarchical. Village society follows a similar pattern – but there the flow is of holy water.

Flooded rice terraces in the central part of Bali, known as 'the rice basket'.

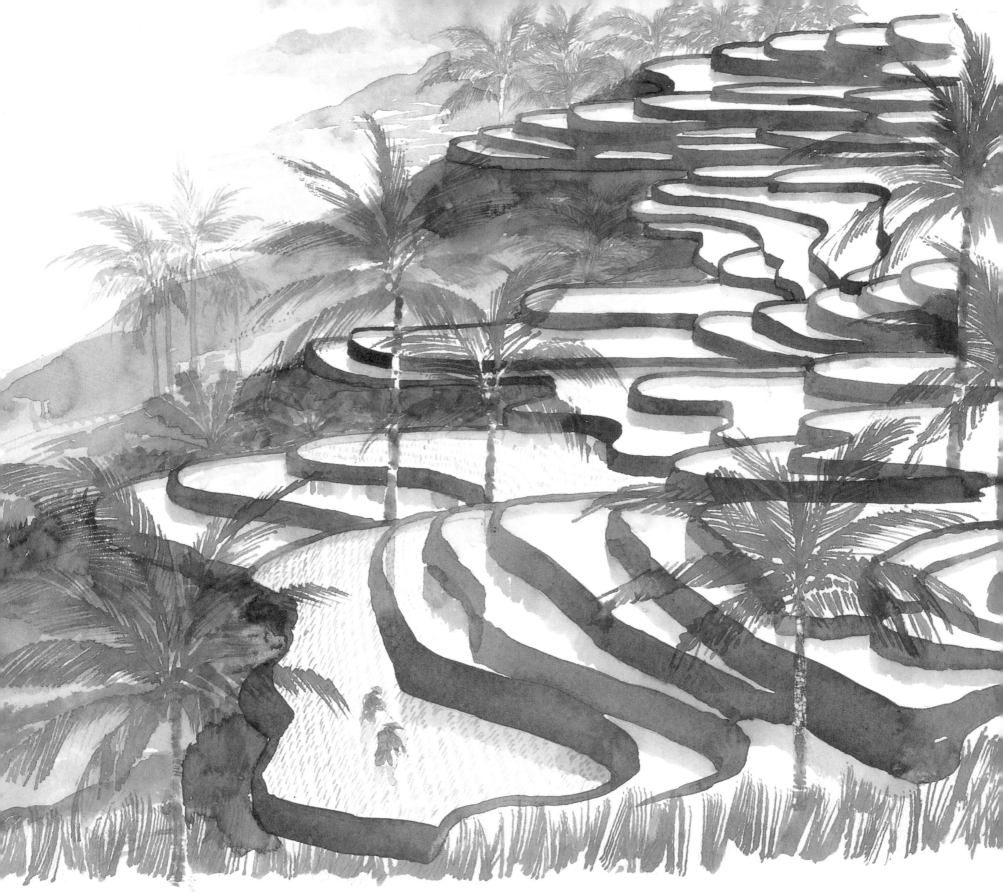

Decorative village sign posts are to
be seen at the entrance and exit of
most Balinese villages.

The great Banyan tree in the
village square, Sudaji. Note how
the branches grow down to the
earth and re-root themselves.

anda tiba di-
DESA APUAN

39962°3½°h

Holy water is the medium by which the gods' blessings are transmitted to people. It is the ultimate focus of Balinese ritual – and ritual is the organizing principle of Balinese society.

In the Hindu-Balinese village, our three-part symbolism becomes very rich. The scheme is seen in village layout as "temples-houses-graveyard", and in the house compound as "house temple-dwellings-back yard". In architecture, it is expressed in the basic building unit, the pavilion (*balé*), where the scheme is "roof-posts-foundation", analogous to "head-body-feet" in the basic unit of society, the human being.

Here in the village, the cosmic mountain appears in temple (*pura*) architecture as shrines and monumental gates, but also as sacred trees – most visibly, in the vast Banyan tree often found at the village centre and fitted out as a shrine. Its mystic function is to be a kind of grounding rod for invisible energies.

As a primordial temple, the sacred tree suggests clues about the nature of man-made temples. Just as a tree is rooted to its place, a Balinese temple is also about "place": it is not a holy building, but a demarcation of holy ground – surrounded by a wall, and open to the sky. Just as a tree extends deep into the ground, so does the mystical anatomy of a temple: this is where the big forces of the Hindu universe – chaos and order – are given homage in cyclical ritual celebrations.

Village society is largely organized around the care and animation of its temples. Yet another expression of the three-part figure is the three-temple nexus of the archetypal Balinese village: the "temple of origins", "community temple", and "temple of the netherworld". Village law is chiefly concerned with maintaining the spiritual purity of the village and regulating the collective work pertaining to rituals. In this sense, the village is a strikingly egalitarian society: in the context of gods and demons, human beings are basically all alike.

This levelling is evident in the layout of a village. Family house compounds are lined up along the village streets (almost always along an upstream-downstream axis), each compound facing onto the street with a conspicuous gate. Since property is privately owned, there are variations in wealth; and this is displayed in the varying degrees of splendour of a house compound's architecture. The basic unit of land, however, is of equal size – generally around 200 square metres – and considered the communal legacy of the village's deified founders.

Exceptions to this uniformity are the *puri*, the grand houses of the formerly ruling aristocracy. These families once commanded great political power through their ability to finance elaborate ritual ceremonies. To this day, the *puri* are still important forces in Bali's religious culture.

Selamat jalan
terima kasih

KKN

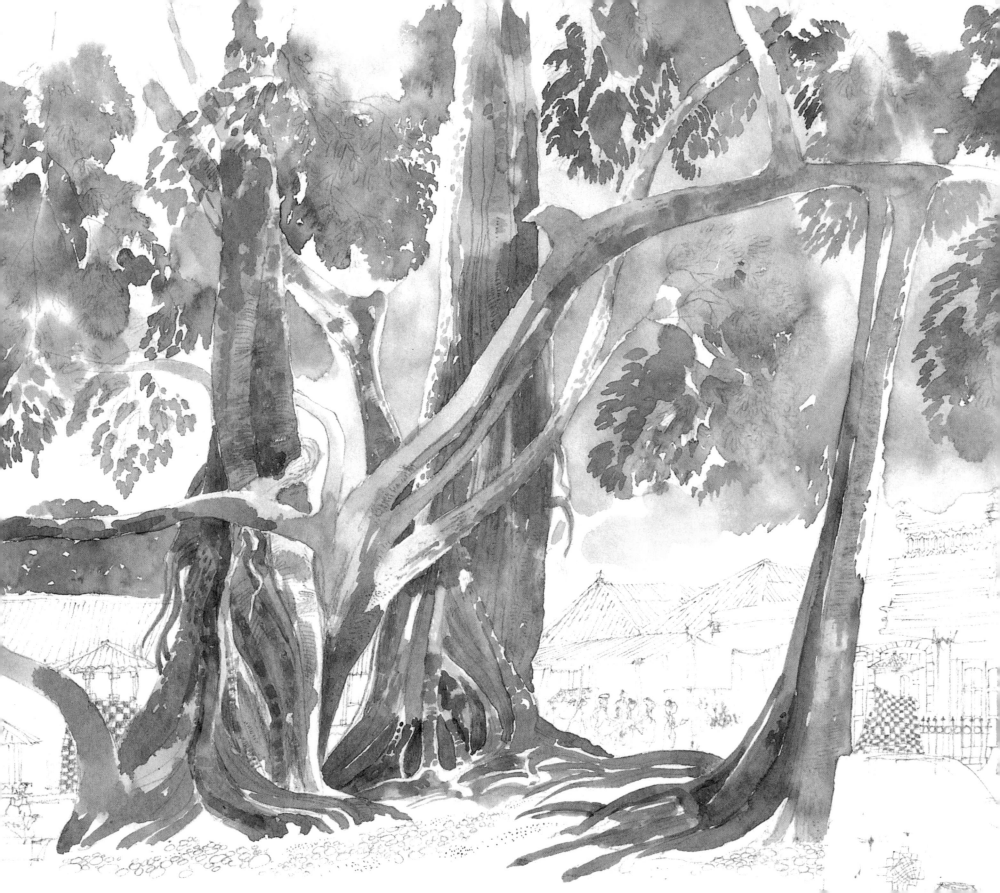

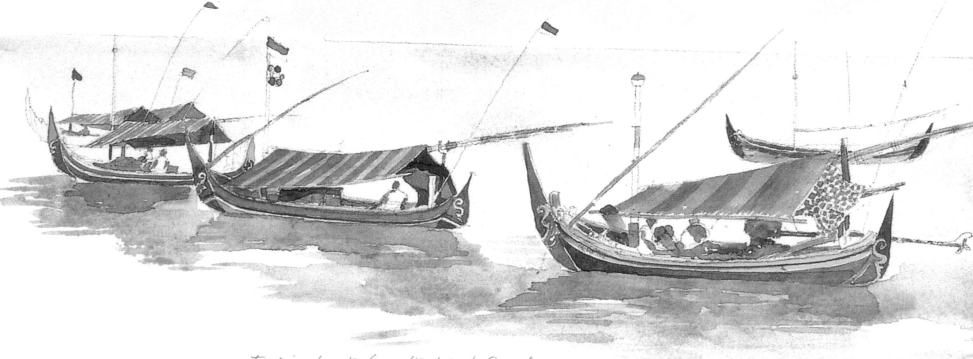

Bali has been described as an inward-looking island, turning away from the sea. While it is true that the Balinese orient themselves inland toward the mountains, they do not shun the sea, but regard it with a fearful respect. This is due partly to their perception of the sea as a place where impurities are dissolved: the ashes of the cremated dead are brought to the sea so that the soul of the deceased may be purified in its netherworldly realms. The cosmic imagery of water now becomes one of sublimation. The purified soul – deified by the prayers of its descendants – rises from the sea like vapour and returns to its original heavenly abode shimmering just above the crown of the holy mountain.

Although the sea is a place of physical and spiritual debris, the Balinese do not consider it unholy or profane. Its powers of transformation, its huge factuality as the edge of the world (that is, of Bali), and the particular treacherousness of its shoals to ships make the sea an entity to venerate. The Balinese do so at shrines called *pura segara* (sea temples) throughout the countryside. There is also a conceptual *pura segara* that lies under the sea.

Nonetheless, most Balinese do not consider the sea coast a desirable place to live. For one thing, the soil is poor; only coconut palms seem to thrive there. Those who do live on the coast turn naturally to fishing and to harvesting other products

Fishing boats from the West Coast

of the sea, such as coral – which they burn to produce lime for building mortar – and a delicious rough sea salt.

There are other reasons for the Balinese to prefer the fertile highlands to the hot lowlands of the coast. Before the advent of modern medicine, the coastal areas were often plagued with cholera, once thought to be a demon who lived on the neighbouring island of Nusa Penida. This fear gave rise to an intense culture of demonology and double-valence medical magic. Its traces are evident throughout the island in trance rituals and the ferocious iconography of guardian statues; but in the lowlands of South Bali, the reverberation of hard-core magic and violent trance remains particularly strong, even among a Balinese middle-class grown accustomed to credit cards, air-conditioning and the hassles of finding a parking space at a temple festival.

Perhaps this is the real nature of Bali's coast: it's a realm of contrast, contradiction, of the resolution of opposites – in short, of changes. Big changes in Bali have always come from beyond its shores. Although the written history of Bali gives only misty accounts of anything that happened more than a hundred years ago, its main events are invasions: from Hindu Java during the first half of the millennium; from colonial Holland in the 19th and early 20th century; from Japan during World War II; and since the 1970s from

almost everywhere through mass tourism.

The idea of the sea coast as Bali's gateway produces some interesting ironies: here is where Balinese souls depart and tourists arrive. In a reversal of the downward flow of water, visitors arrive at the coast and venture inland, upstream. The pinnacle of the tourist itinerary is a visit to the volcano, Mount Batur. Should we conclude that tourism is somehow contrary to the cosmic order?

No. The image of the flow of water is, after all, circular – descending from the mountain to the sea, then rising again to become rain. And tourism has not only brought economic nourishment to Bali, but it has also reinforced the confidence of the Balinese in their culture as a true guide for living.

Bali's destiny as a tourist haven has much to do with its extraordinary culture, which was "discovered", admired and made famous by a small élite of Western travellers in the 1930s. The colonial Dutch encouraged a strictly supervised sort of tourism to Bali with the hope of promoting their image as enlightened colonists. After independence, the new Republic of Indonesia also saw a role for Bali as its "window to the world".

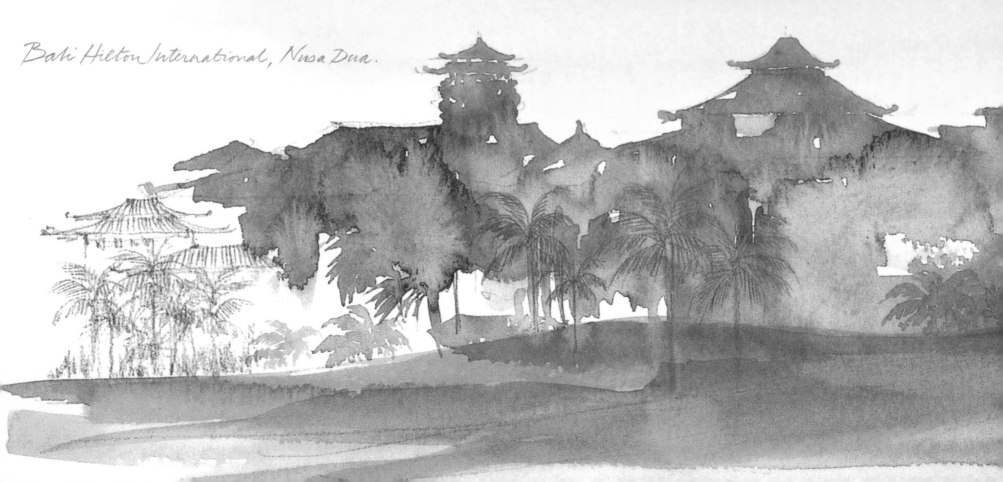

Bali Hilton International, Nusa Dua.

Moreover, tourism was widely thought to be an ideal development strategy that would earn foreign currency and be less disruptive than heavy industry. In Bali, it was decided that the natural venue for tourism was the southern coast.

It is not surprising, then, that the most important architectural monuments on the coast are seaside temples and tourist hotels, nor that hotel architecture consciously – even conscientiously (for this is official policy) – draws on traditional Balinese building styles. As the sociologist Michel Picard has shown, tourism and Balinese culture itself have joined in a new dynamic in which they are becoming almost inseparable.

As to Bali's future, the three-part concept that we have been following provides a clue to its continually successful evolution. In its various expressions, the central figure is always the human being. Humankind mediates between the upper and lower worlds through the balancing action of ritual. Similarly, the Balinese believe that they can best address the challenges of the future by remaining faithful to the spiritual legacy of their ancestors – an exercise in balancing that may require all their considerable charm, imagination, and skill.

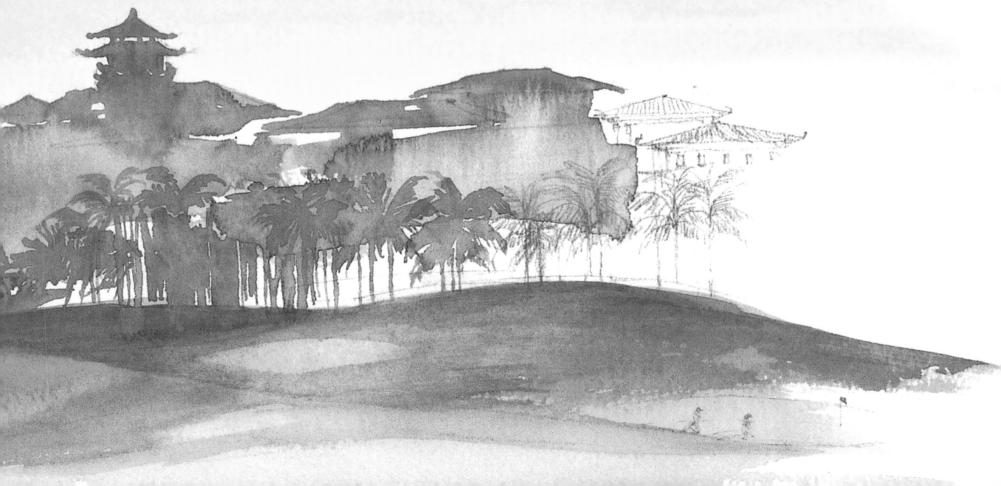

Part One
The World of Origins

The mountains of Bali give off an almost electrical charge of supernatural power. To the east is the radiantly solitary volcano Gunung Agung, Bali's highest mountain. The brooding Gunung Batur and its lake cast a dark magical glamour over the central region of Kintamani; and to the west, Gunung Batukaru stands as a sentinel over the lakes Bratan, Buyan, and Tamblingan.

In this chilly pristine world, the deities of mountains and lakes are honoured at some of Bali's most important temples. The temple complex Pura Besakih (pages 26–27) is a sort of capital city of deified ancestors. The lake temples of Batur and Bratan (pages 34–37) are fundamentally agricultural temples, with vast congregations from downstream.

Mountain villages adhere to a culture that pre-dates, and remains unimpressed by, the aristocratic Javanese influence of 16th-century Majapahit. Village layout is grid-like, and the uniformity of the houses reflects a severe social code. Whether of timber and bamboo or the more recently fashionable concrete and tin, houses have steep roofs and snug smoky itchens, as shelter against the cold mountain rains.

On the sunny northern slopes, mountain villages show traces of exposure to foreign cultures. Munduk village (pages 30–33) was once a rest-stop for Dutch colonial officials inspecting coffee plantations.

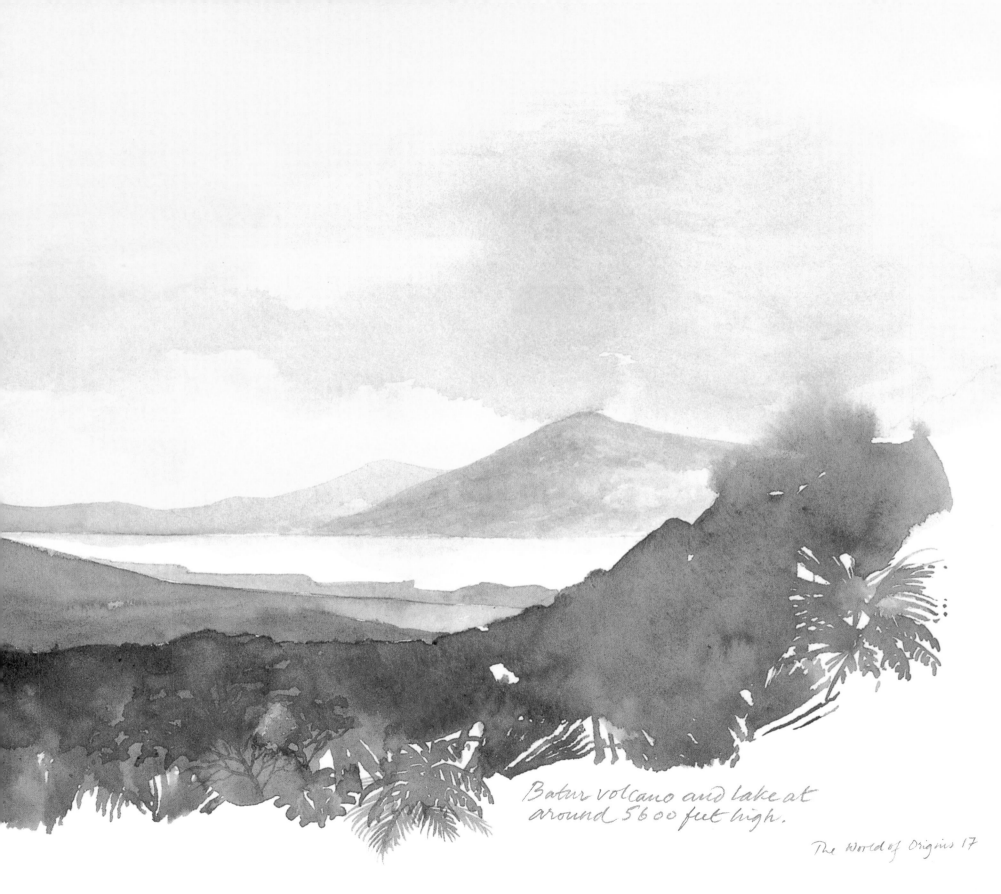

Batur volcano and lake at
around 5600 feet high.

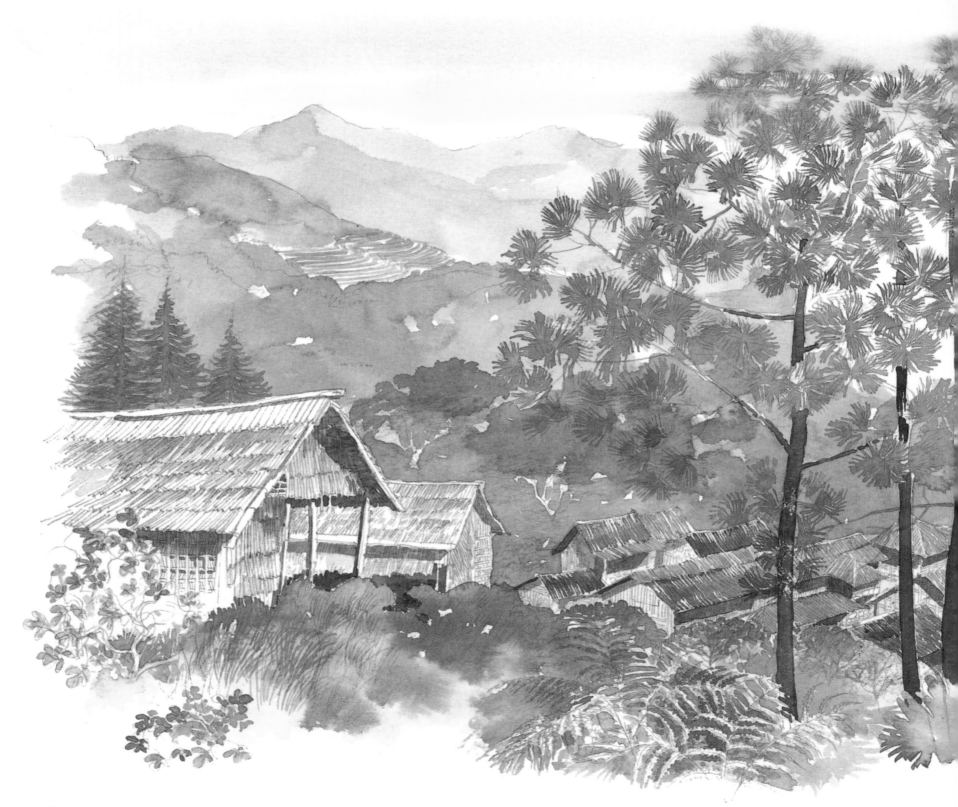

Sukawana. Mountain village with rusting tin roofs, and a strange mixture of pine trees & tropical growth

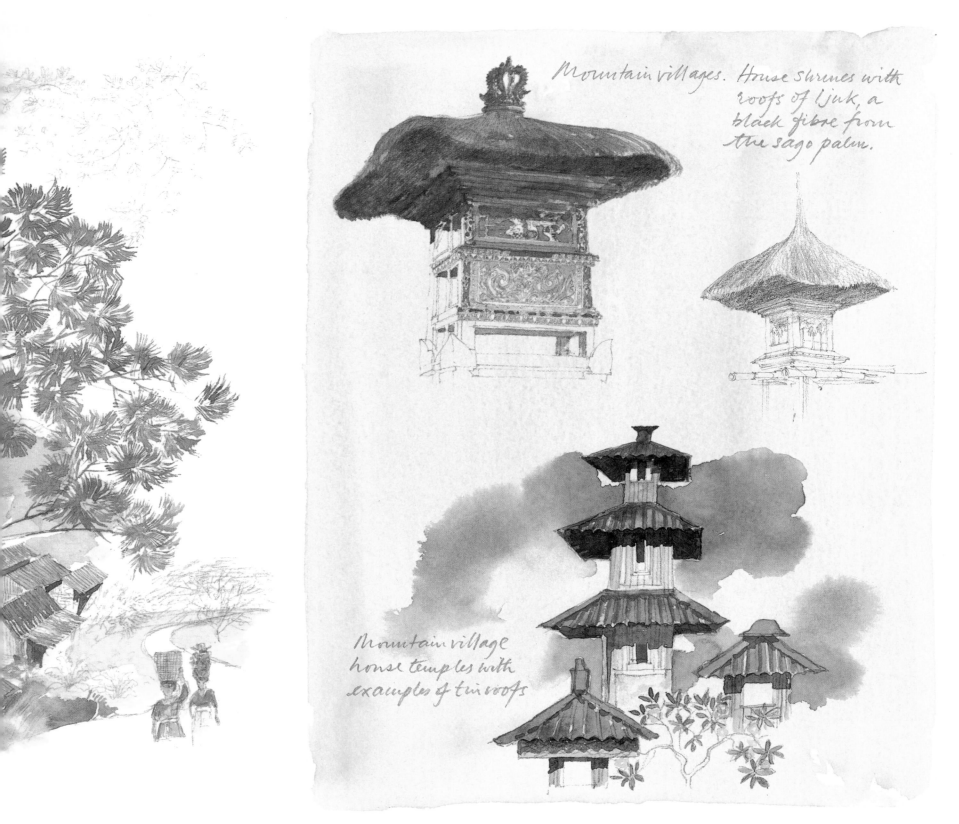

Mountain villages. House shrines with roofs of Ijuk, a black fibre from the sago palm.

Mountain village house temples with examples of tin roofs

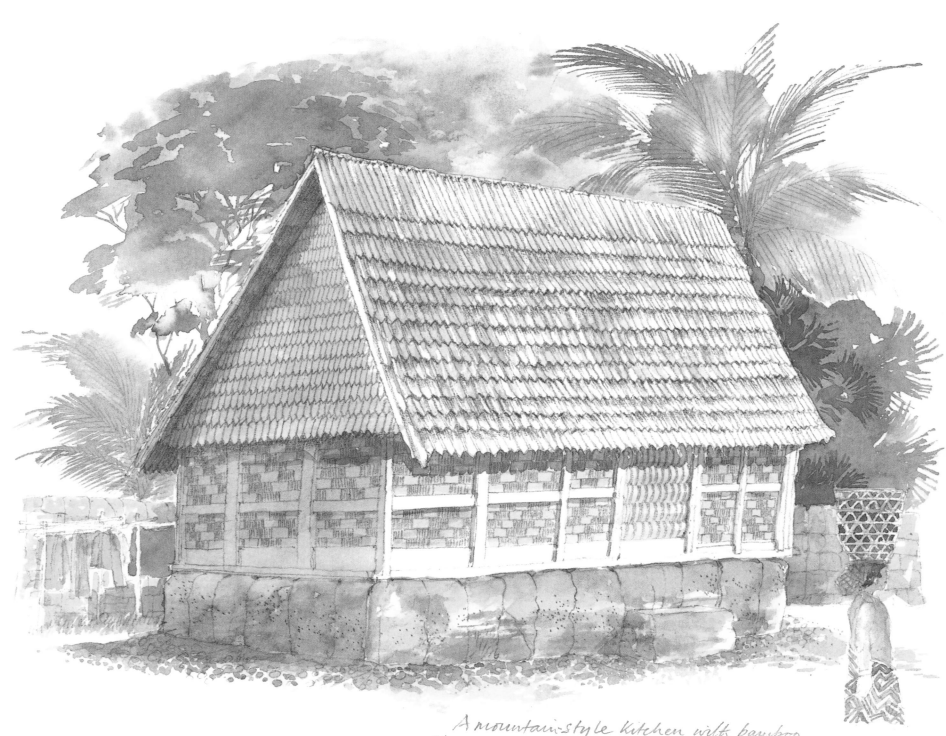

A mountain-style kitchen with bamboo
shingles and walls of woven bamboo. The
base is made out of mud bricks.

A decorative top in
terracotta adorns this
temple roof made out
of bamboo shingles

Mountain village
building styles

House gate of mud and thatch.

Modern wealth blurs regional styles—
a substantial gate like this can be found
anywhere in Bali

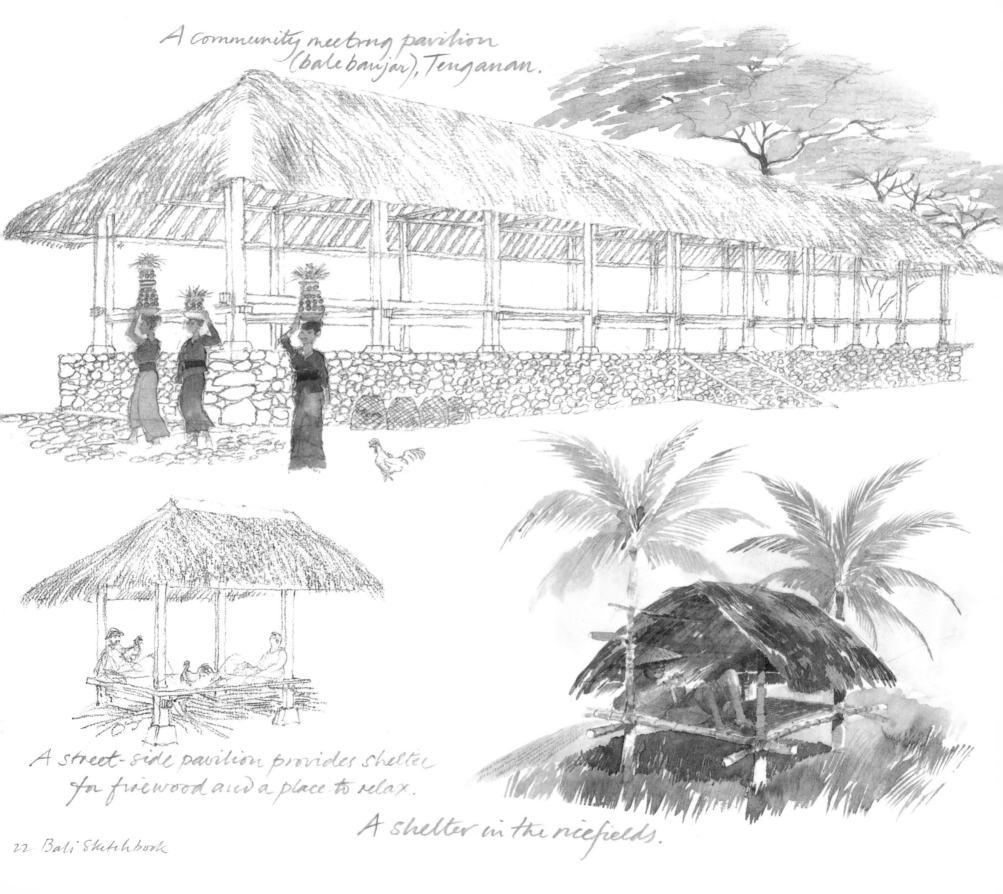

A community meeting pavilion
(bale banjar), Tenganan.

A street-side pavilion provides shelter
for firewood and a place to relax.

A shelter in the ricefields.

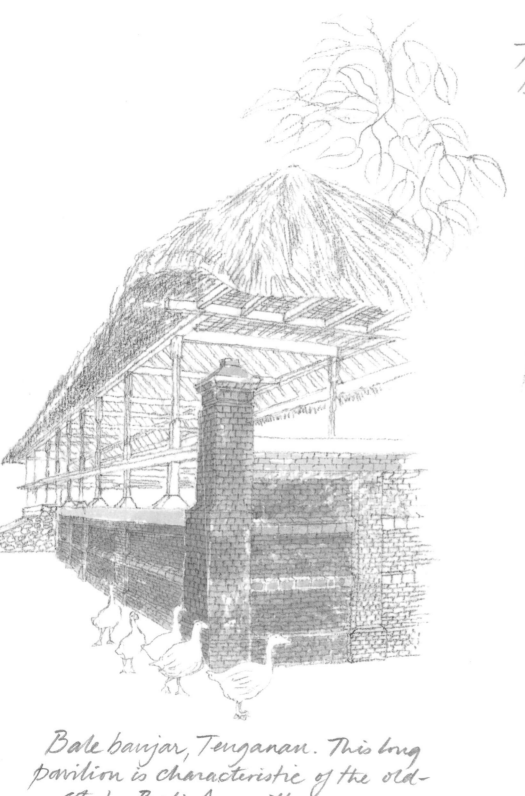

Bale banjar, Tenganan. This long
pavilion is characteristic of the old-
style Bali Aga villages

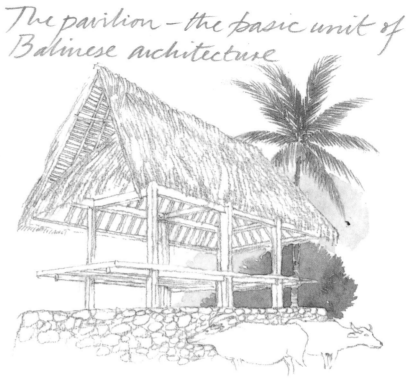

The pavilion – the basic unit of
Balinese architecture

Rice barn, Tenganan.

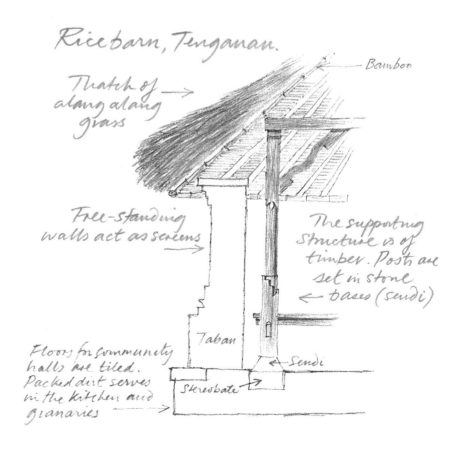

Thatch of → alang alang grass

Bamboo

Free-standing walls act as screens

The supporting structure is of timber. Posts are set in stone ← bases (sendi)

Taban

← Sendi

Floors for community halls are tiled. Packed dirt serves in the kitchen and granaries →

Stereobate →

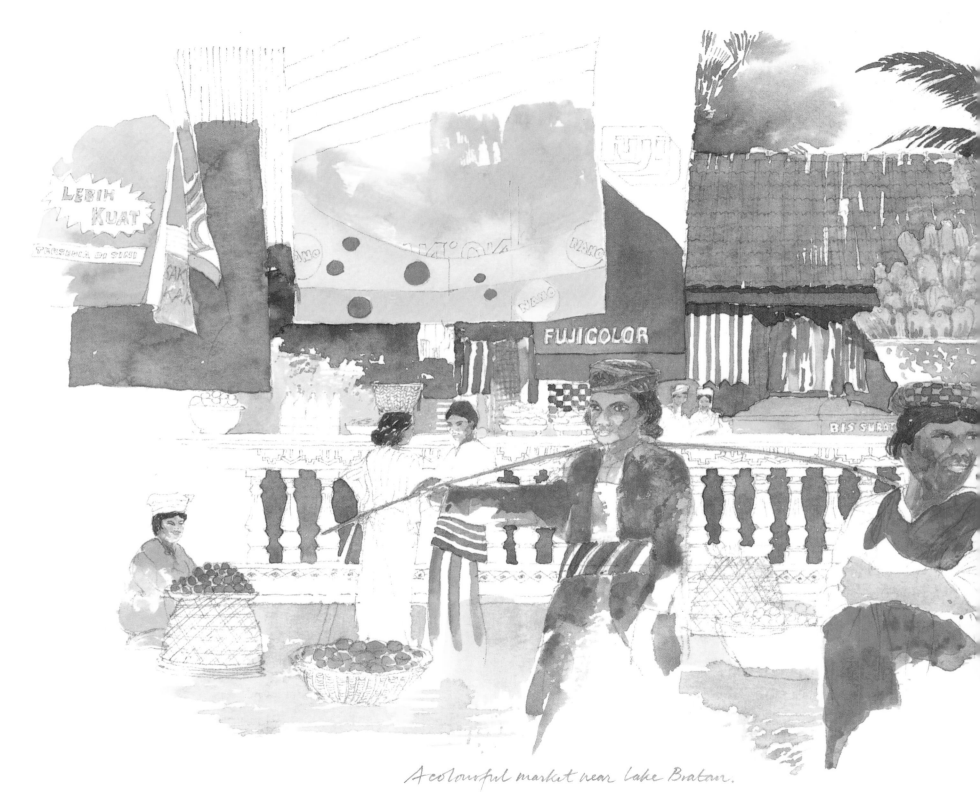

A colourful market near Lake Bratan.

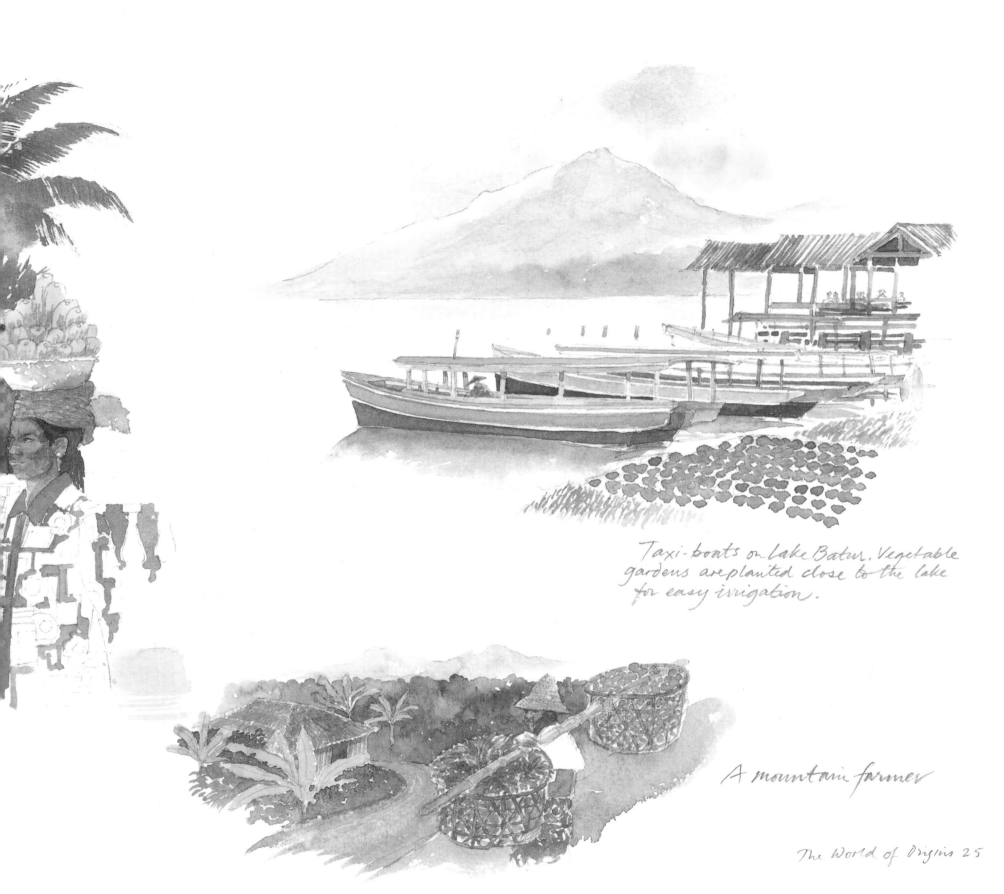

Taxi-boats on Lake Batur. Vegetable gardens are planted close to the lake for easy irrigation.

A mountain farmer

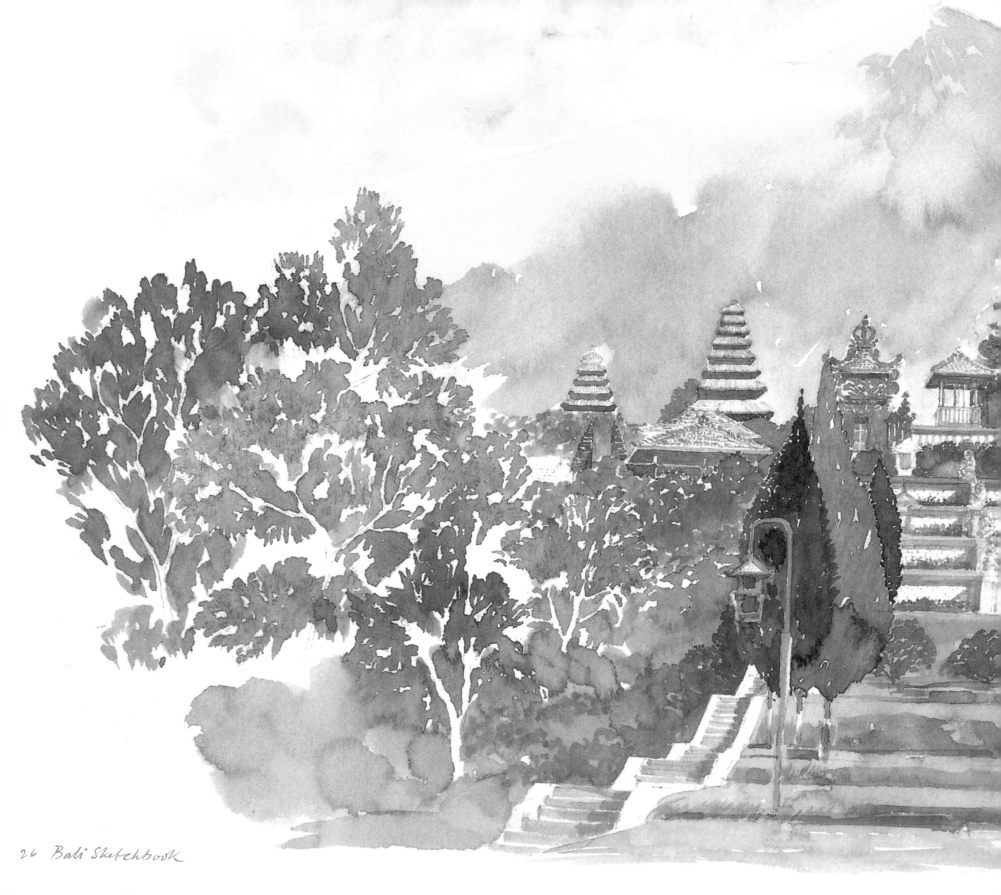

26 Bali Sketchbook

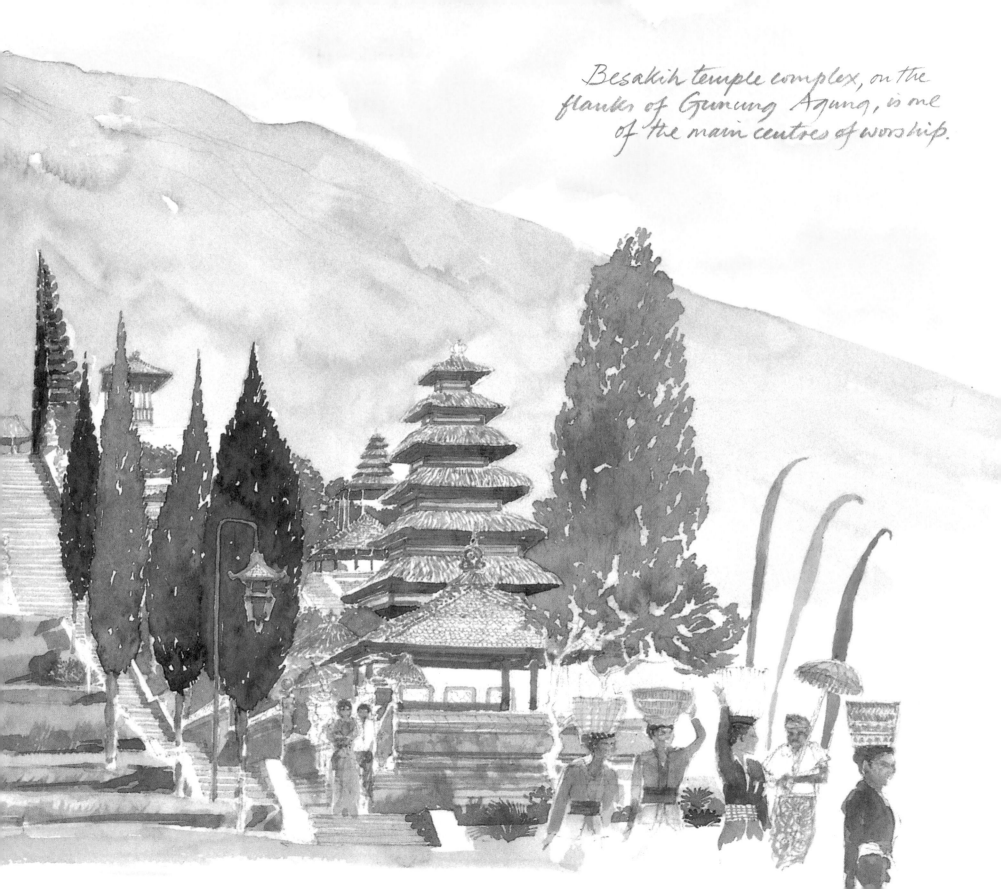

Besakih temple complex, on the flanks of Gunung Agung, is one of the main centres of worship.

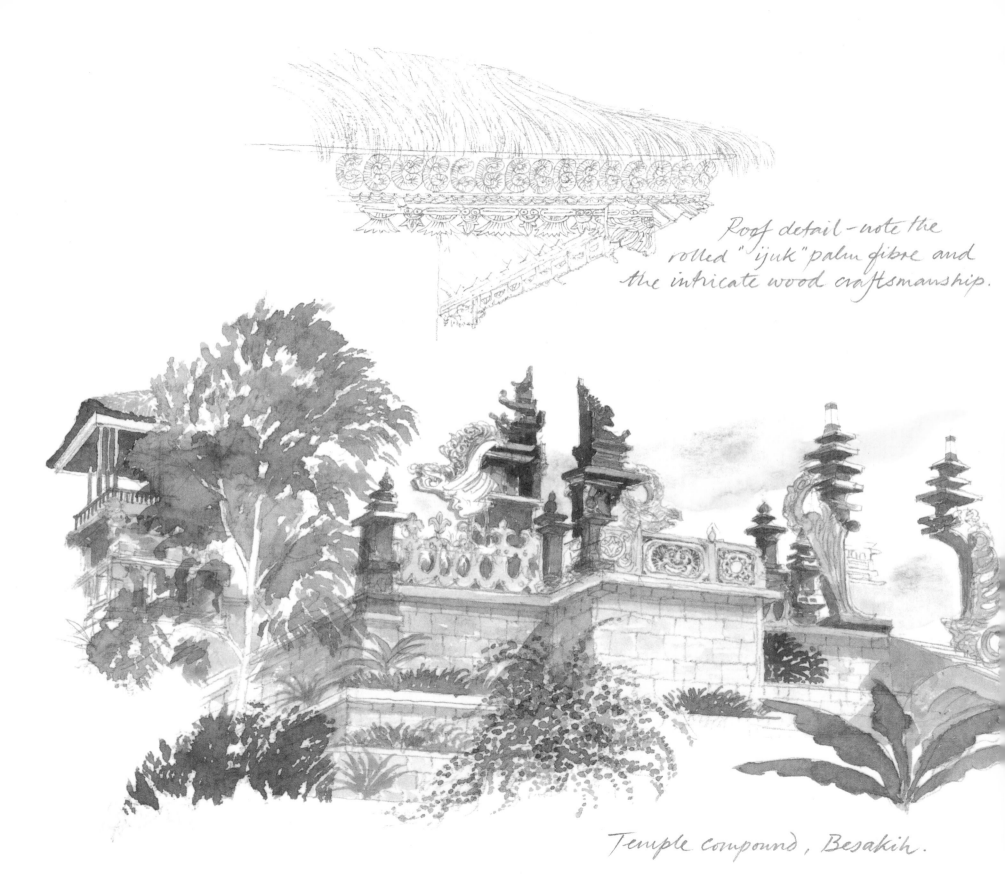

Roof detail – note the rolled "ijuk" palm fibre and the intricate wood craftsmanship.

Temple compound, Besakih.

Details from Pura Besakih.

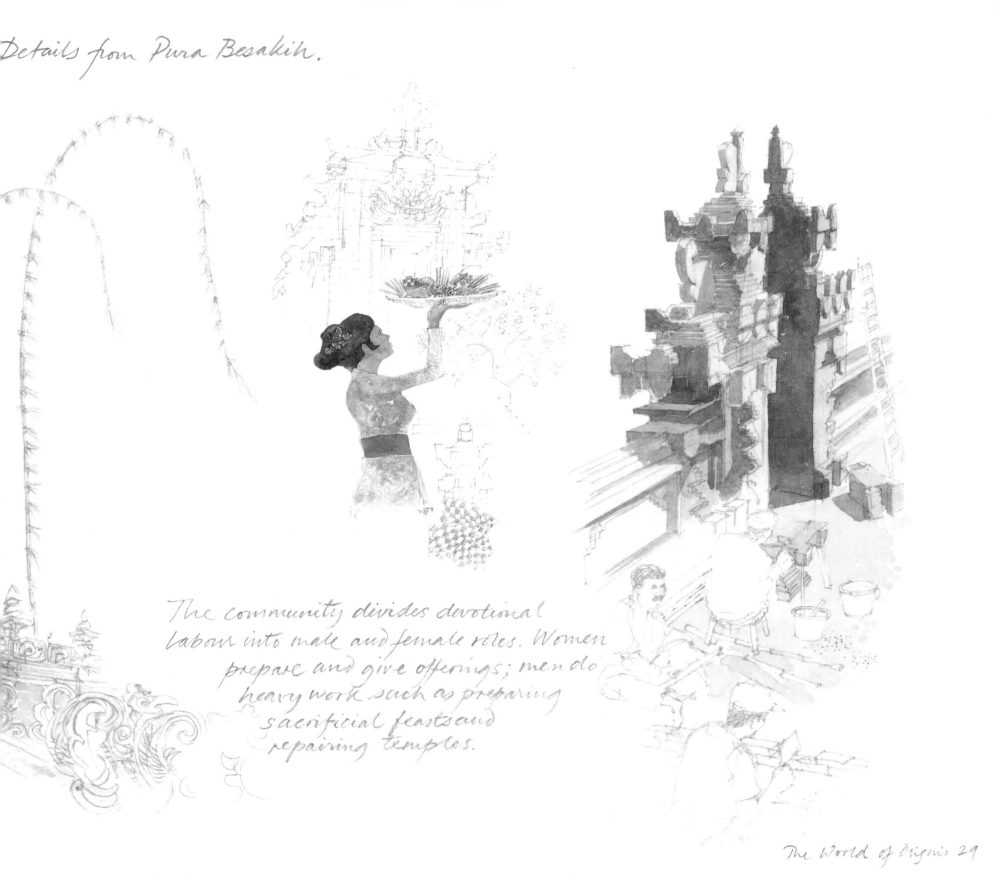

The community divides devotional
labour into male and female roles. Women
prepare and give offerings; men do
heavy work such as preparing
sacrificial feasts and
repairing temples.

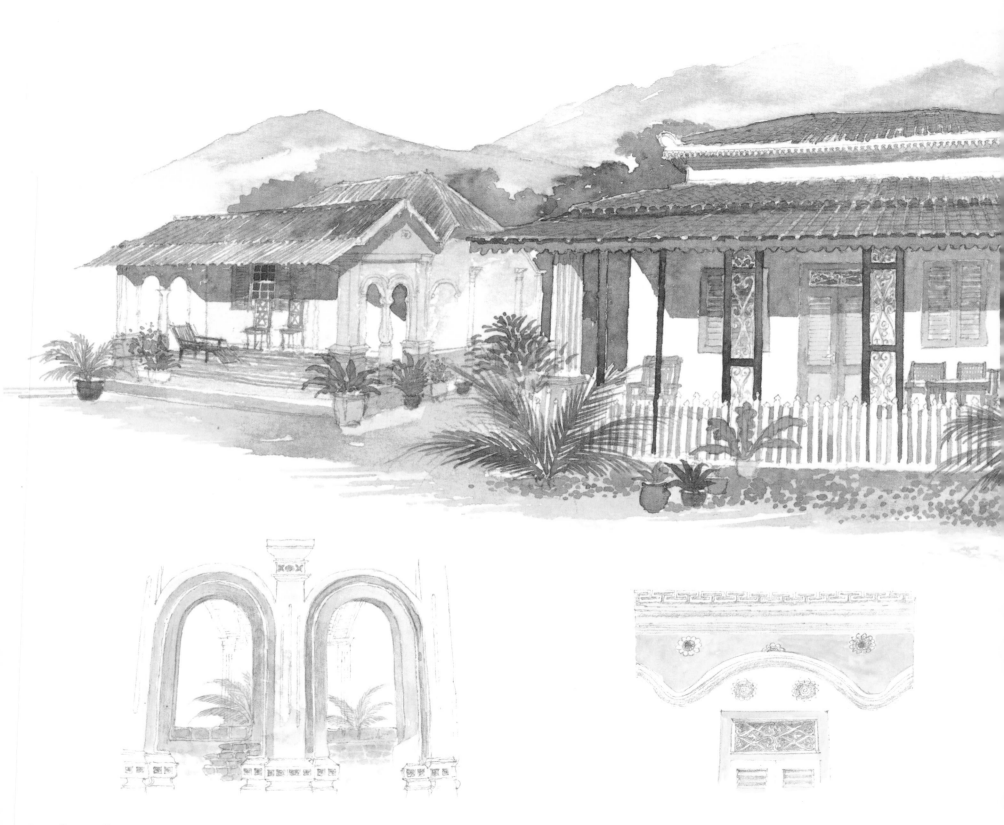

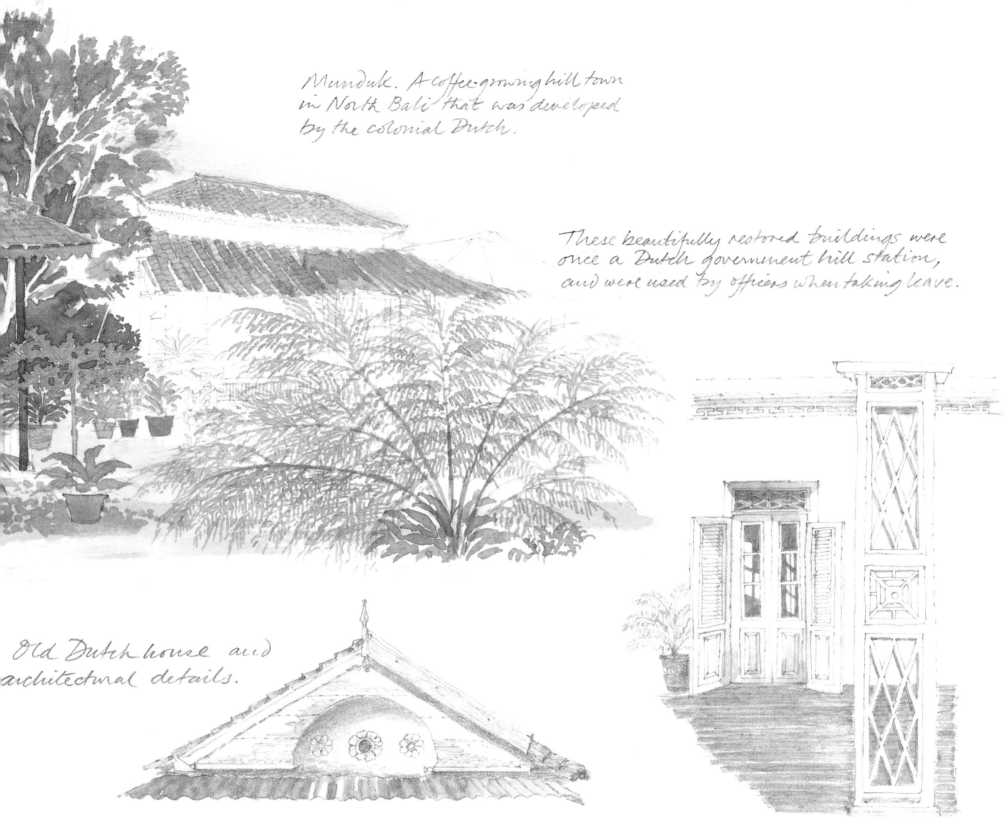

Munduk. A coffee-growing hill town in North Bali that was developed by the colonial Dutch.

These beautifully restored buildings were once a Dutch government hill station, and were used by officers when taking leave.

Old Dutch house and architectural details.

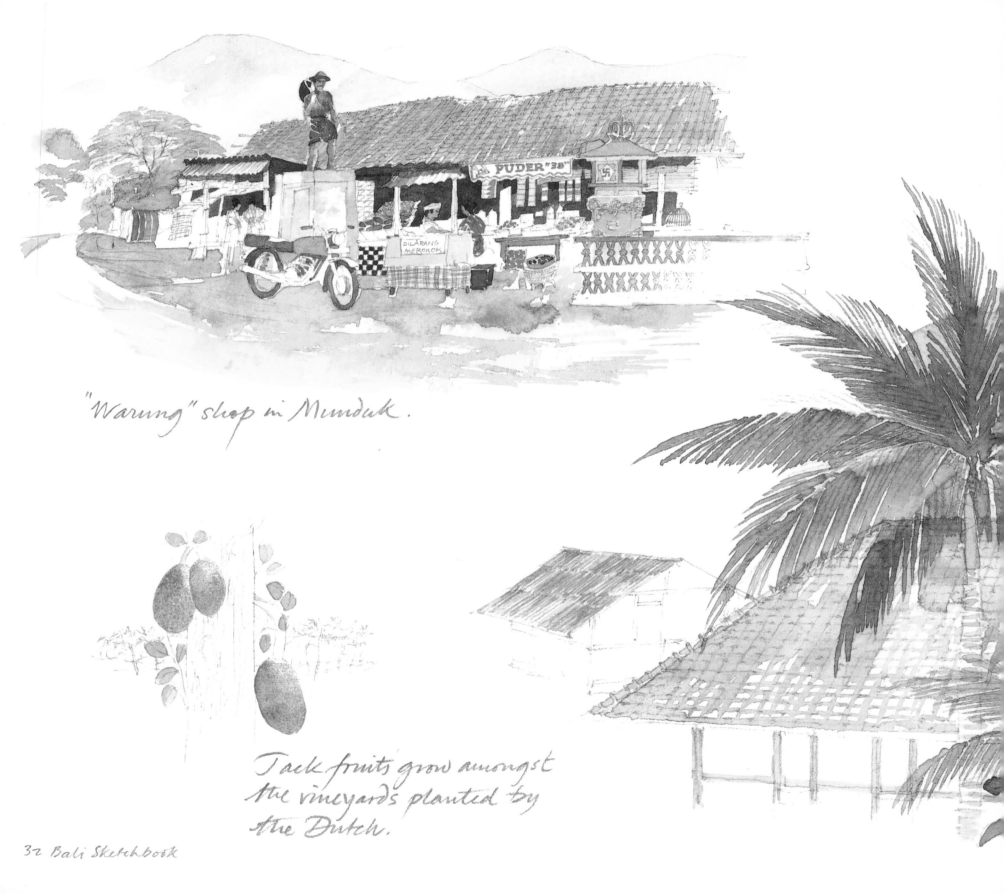

"Warung" shop in Munduk.

Jack fruits grow amongst
the vineyards planted by
the Dutch.

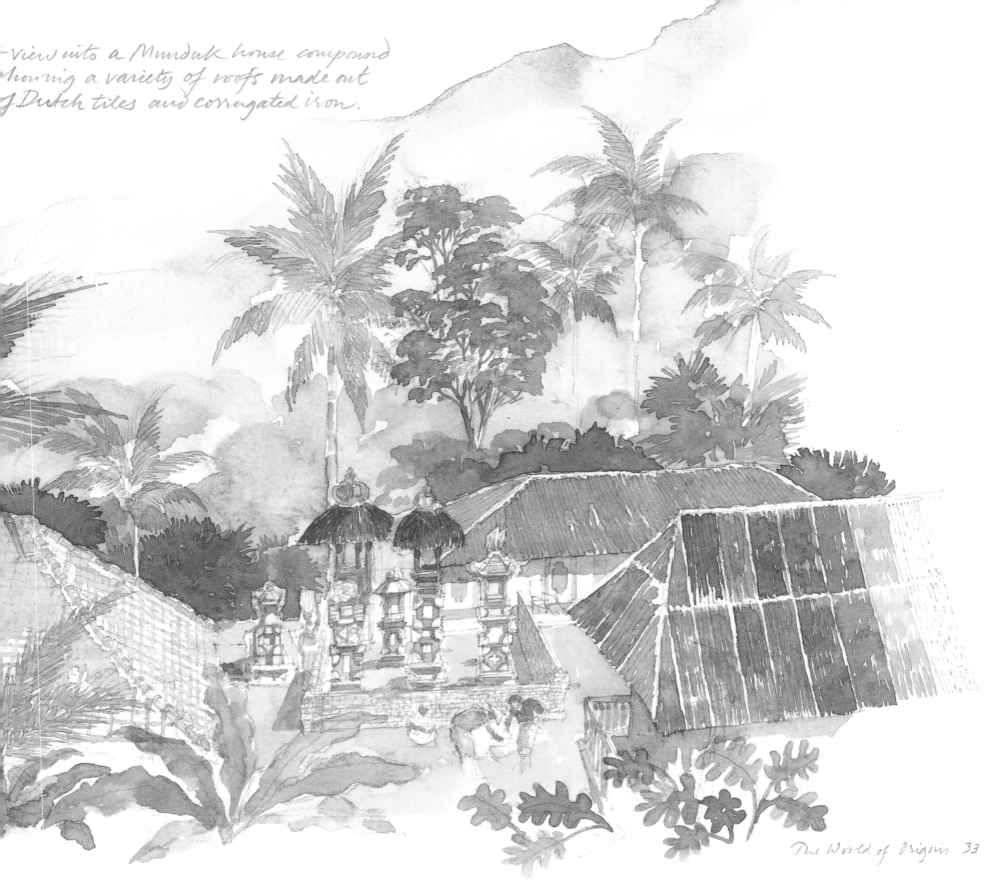

view into a Munduk house compound showing a variety of roofs made out of Dutch tiles and corrugated iron.

Puru Ulun Danu Batur
(Karang Anyar).
Dedicated to the Goddess
of Lake Batur

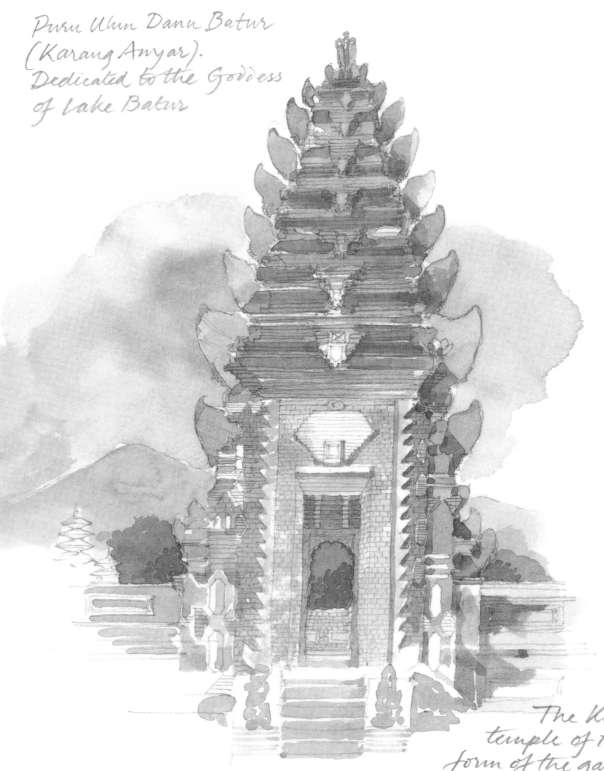

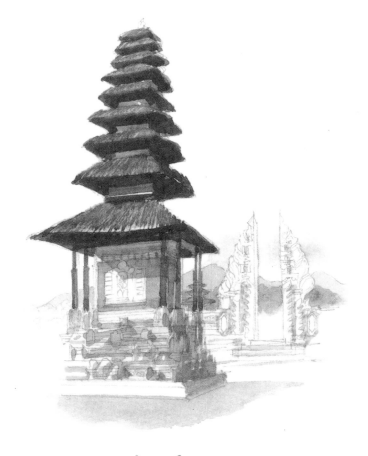

Pagoda (meru) and
split gate leading to
another courtyard.

The Kori Agung (great gate) at the
temple of the Goddess of Lake Batur. The
form of the gate represents the cosmic mountain.

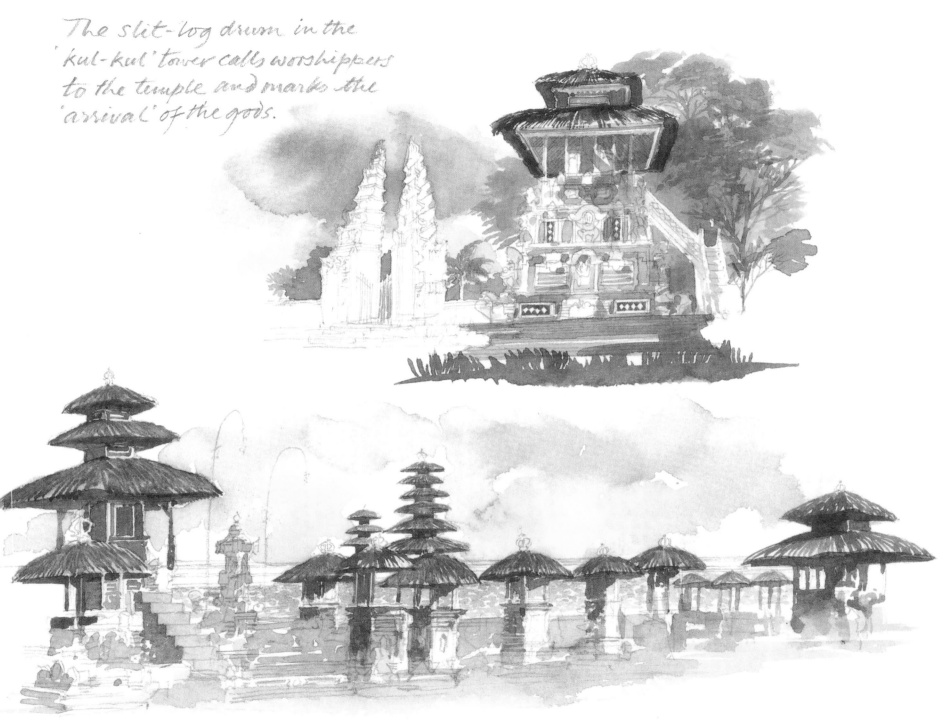

The slit-log drum in the 'kul-kul' tower calls worshippers to the temple and marks the 'arrival' of the gods.

Shrines at the Lake Temple, Batur. Roofs are made of black palm fibre (ijuk). The number of tiers indicates the deity's rank.

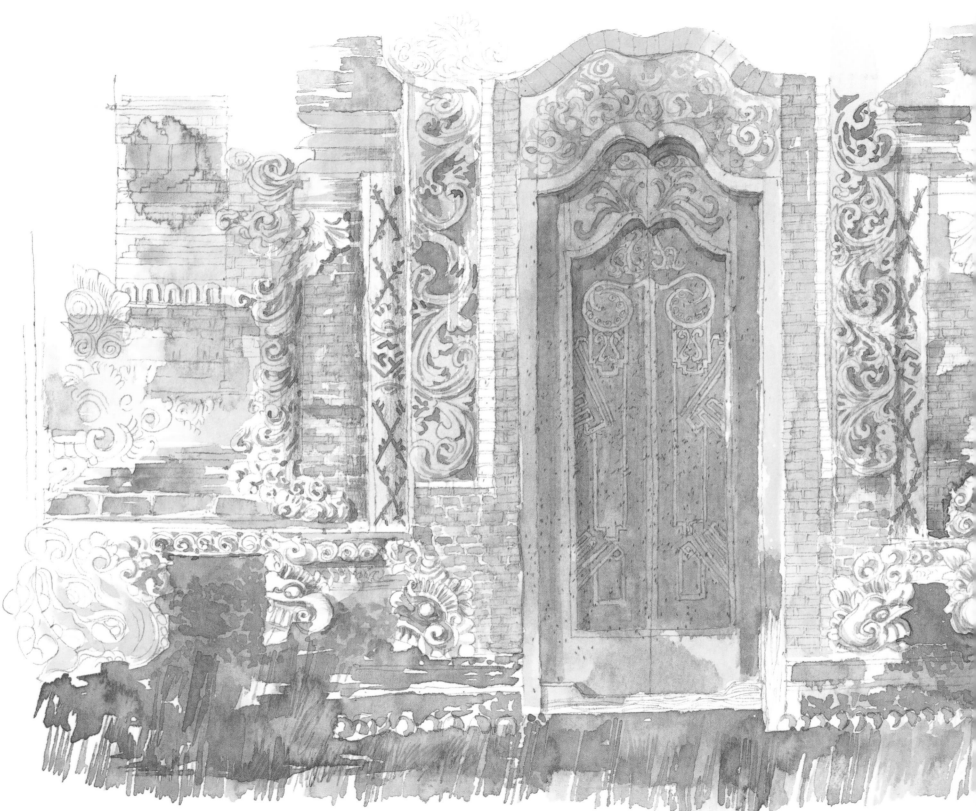

36 Bali Sketchbook

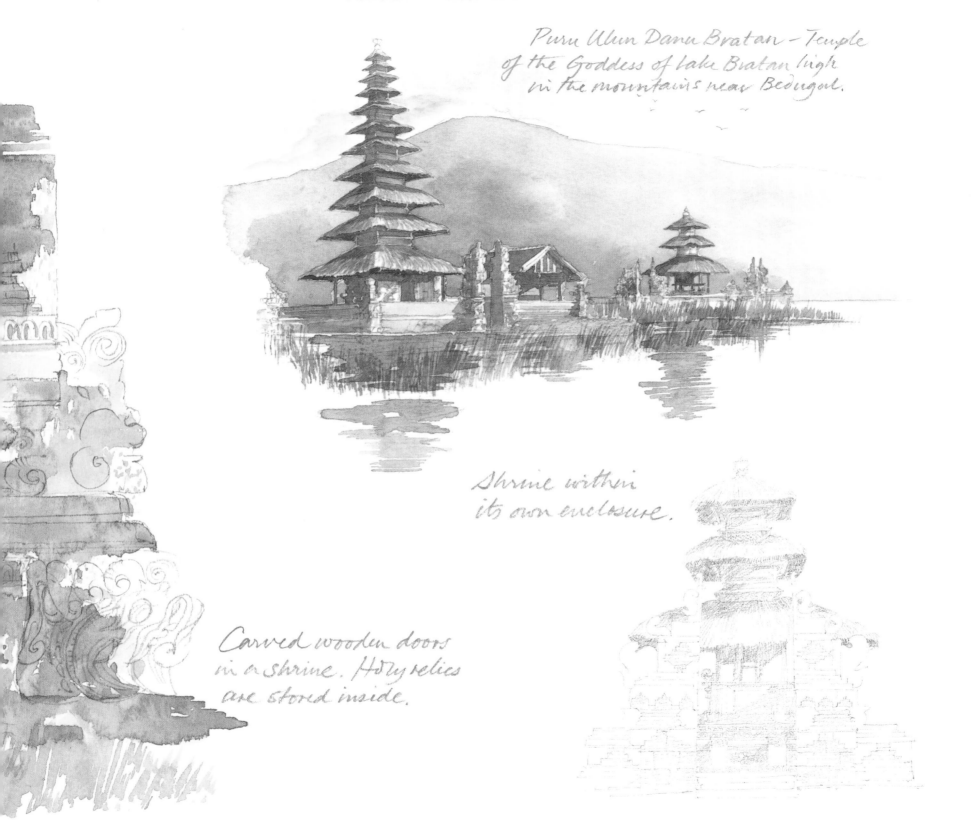

Puru Ulun Danu Bratan – Temple
of the Goddess of Lake Bratan high
in the mountains near Bedugul.

Shrine within
its own enclosure.

Carved wooden doors
in a shrine. Holy relics
are stored inside.

Part Two
The Hand-Made World

The rice-growing regions of Bali are part of a landscape whose surface is almost entirely man-made. The human hand has shaped rice terraces, planted groves and gardens, and carved reliefs into the stony sides of river gorges. Above all, the Balinese have embellished their earth with villages, palaces and temples.

The village centre shown on pages 44–45 is an expressive image of the idea of the village as microcosm. The Banyan tree is suggestive of the tremendous force of nature; the temple's split-gate represents the world of spirit; and the *kul-kul* drum tower, for summoning villagers, represents the human community. The unifying social force of the village is apparent in its architectural patterns. Village streets are public gathering places, while the outdoor spaces of the house compound are where families gather and most activities take place. Even villages that have been transformed by tourism – such as Ubud (pages 56–57) – are still primarily focused around their temples.

Balinese nobility have for centuries been patrons of Bali's arts, employing the Balinese genius for ornamentation to heights of virtuosity. Temples, too, are venues of elaborate craftsmanship. The relationship between palaces (*puri*) and temples (*pura*) is intimate and complex. Many temples were founded by kings, and some (like the one shown on pages 64–65) are dynastic palace temples.

Bali's ricefields are terraced into the island's broad central slopes, irrigated by man-made channels that flow from the mountain springs and empty into the sea.

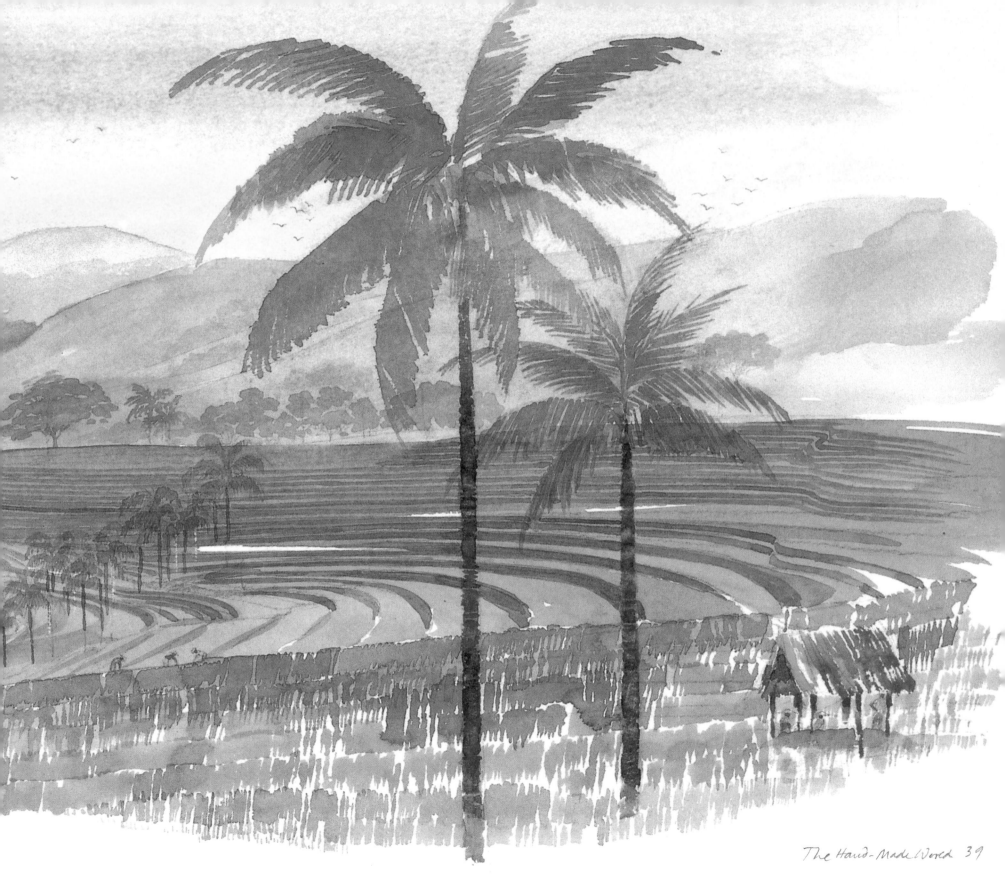

The women in the ricefields wear woven hats which help to shade them from the tropical sun.

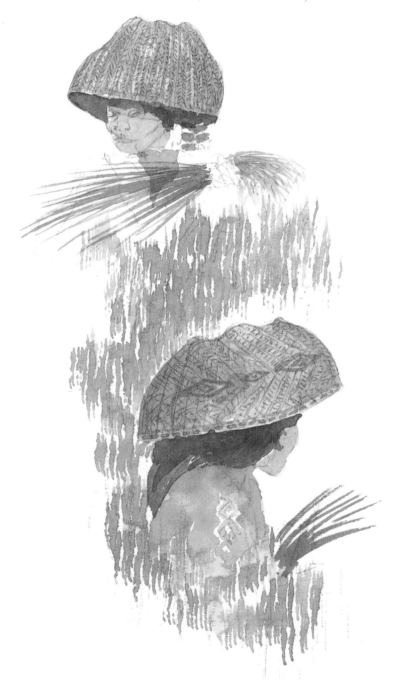

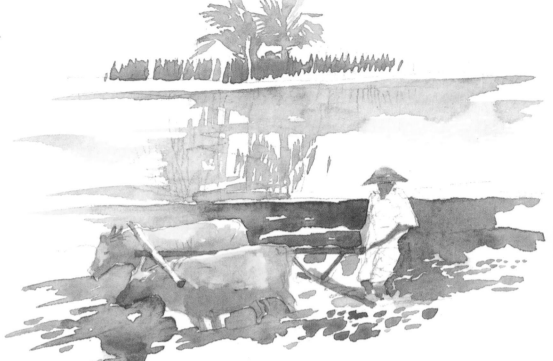

Ploughing is still done with two of the family cattle.

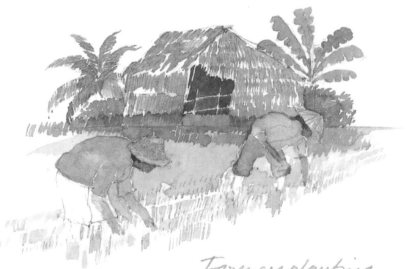

Farmers planting the rice seedlings which can be done at least three times a year.

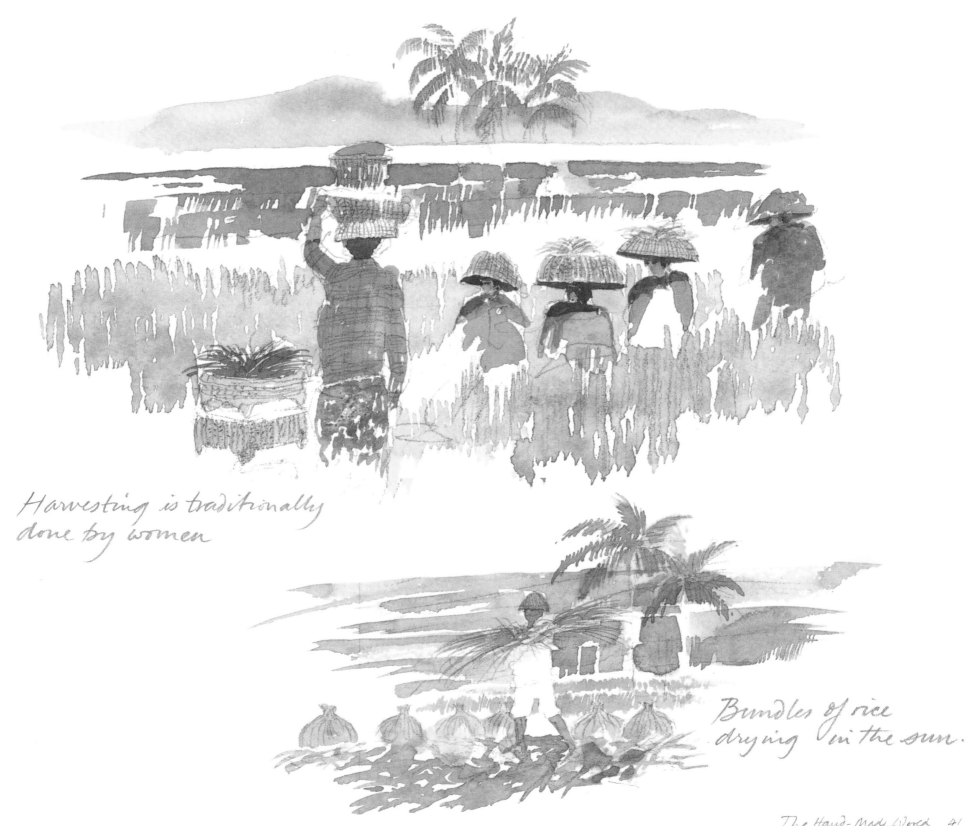

Harvesting is traditionally
done by women

Bundles of rice
drying in the sun.

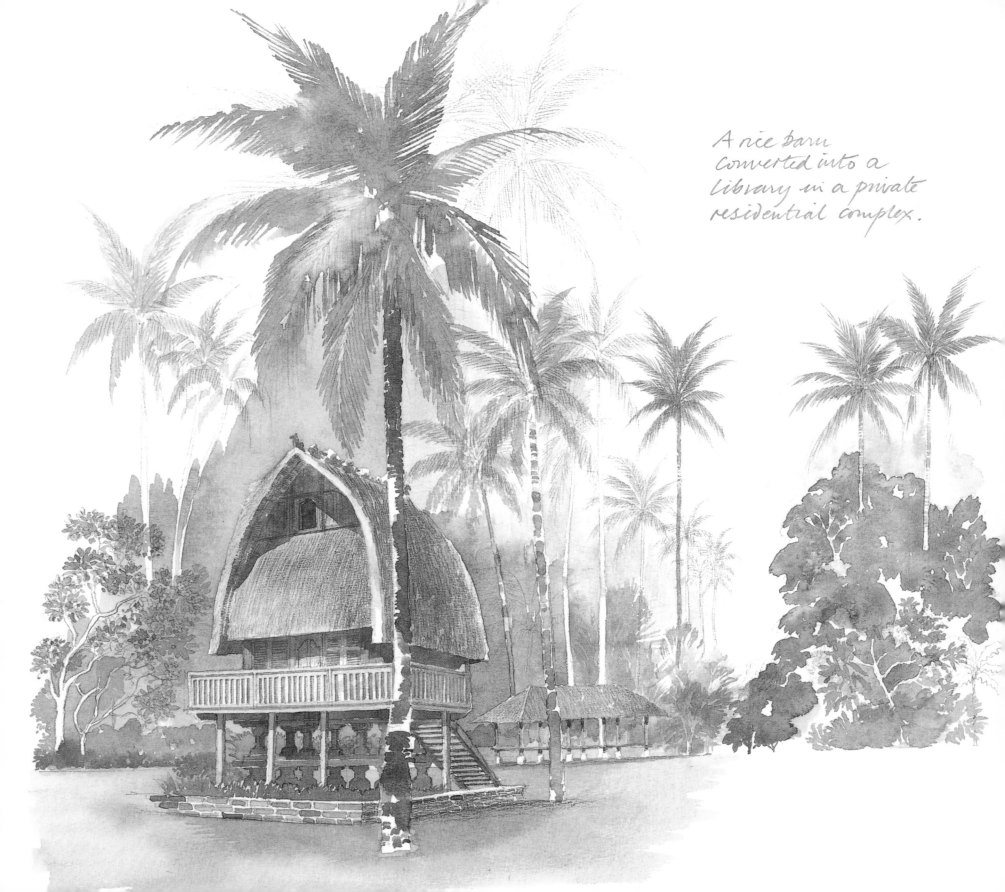

A rice barn
converted into a
library in a private
residential complex.

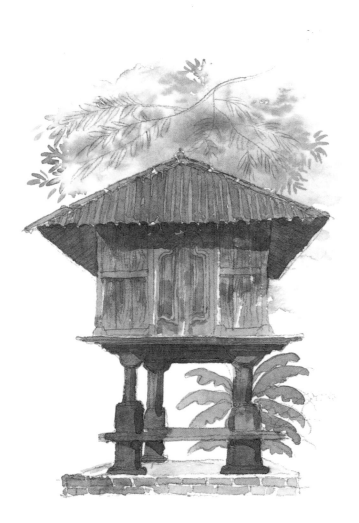

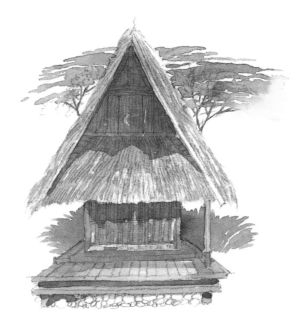

Rice barns for storing
grain show a variety
of regional styles.
The lower platform

The lower platform
sometimes serves as
a shady workspace.

Rat guard on the
supporting posts
underneath the
grain storage level.

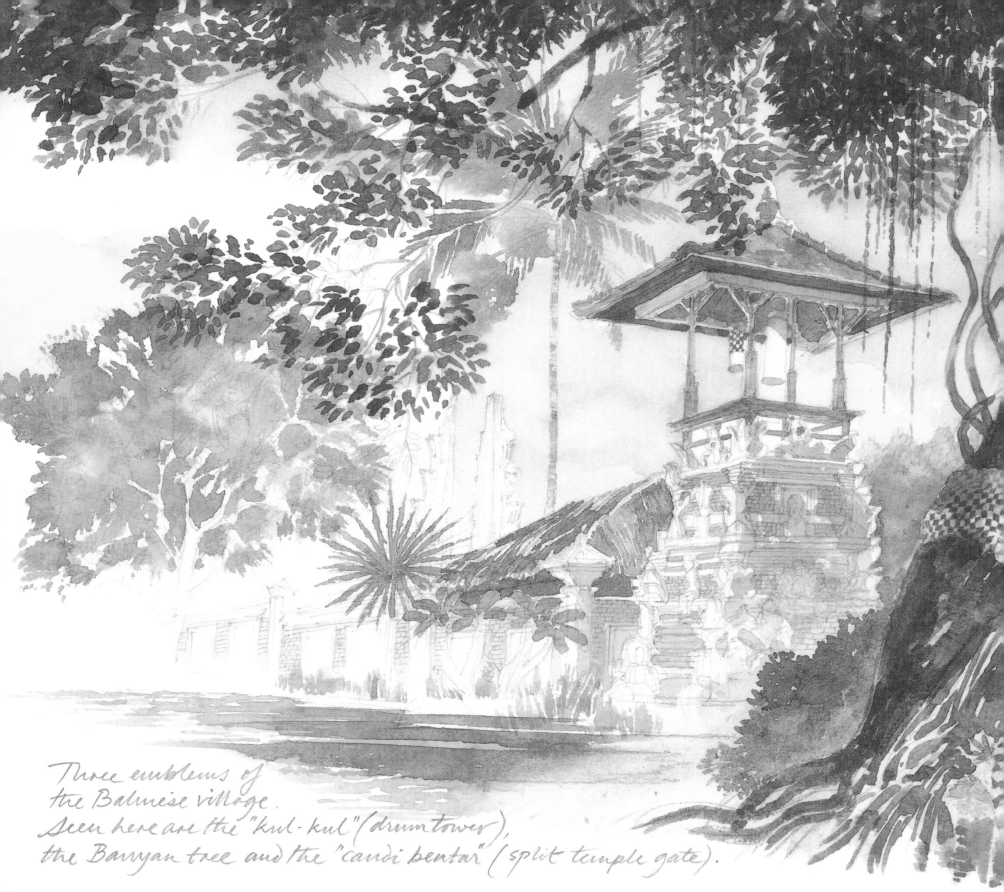

Three emblems of
the Balinese village.
Seen here are the "kul-kul" (drum tower),
the Banyan tree and the "candi bentar" (split temple gate).

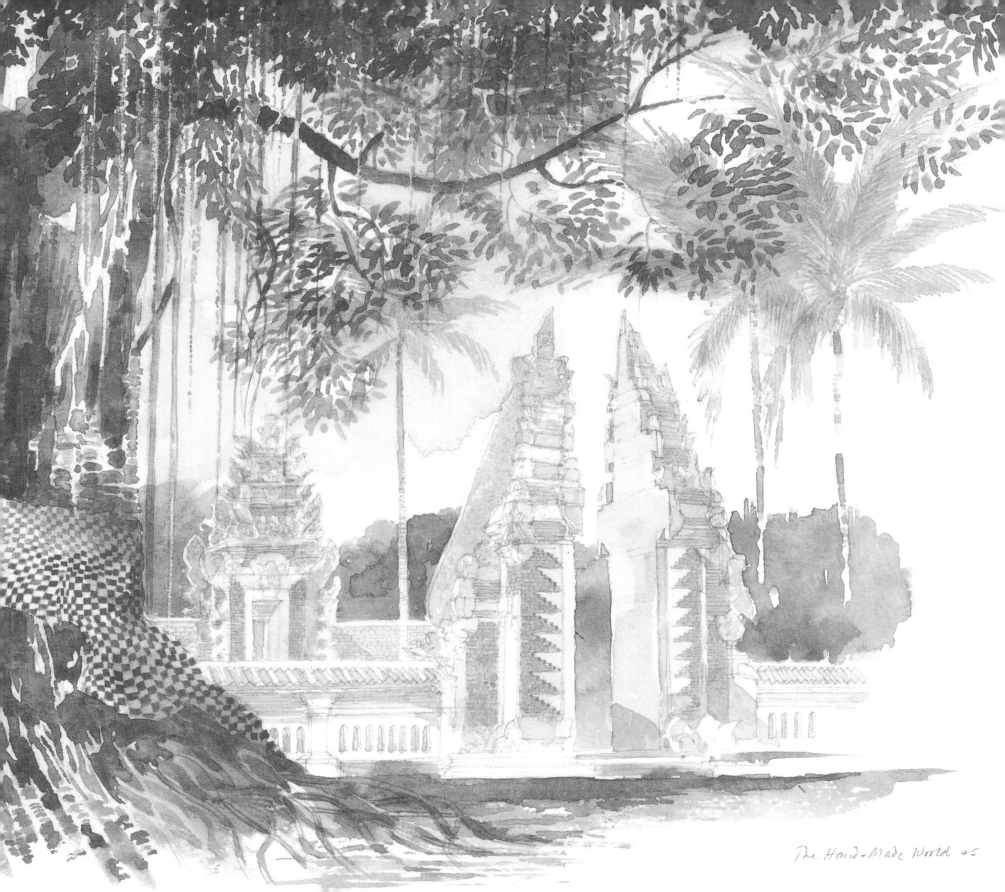

The Hand-Made World 45

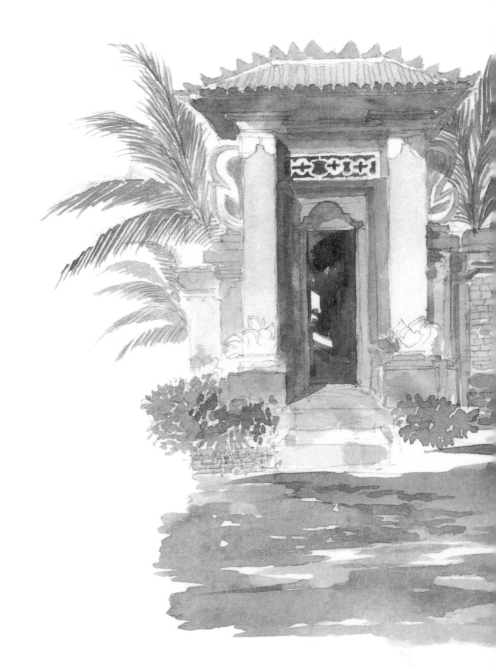

Village streets are lined with distinctive roofed gateways into family compounds.

The itinerant soup vendor with his two-wheeled cart is called 'kaki lima', meaning 'five feet'.

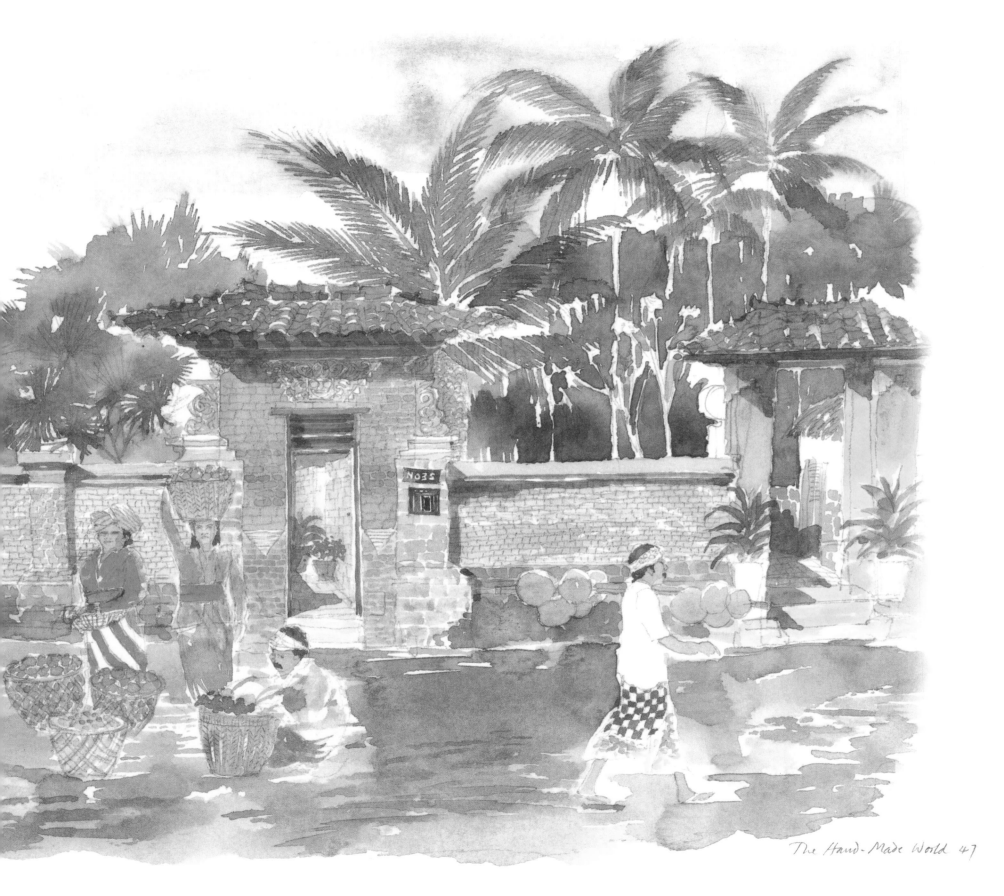

The Hand-Made World 47

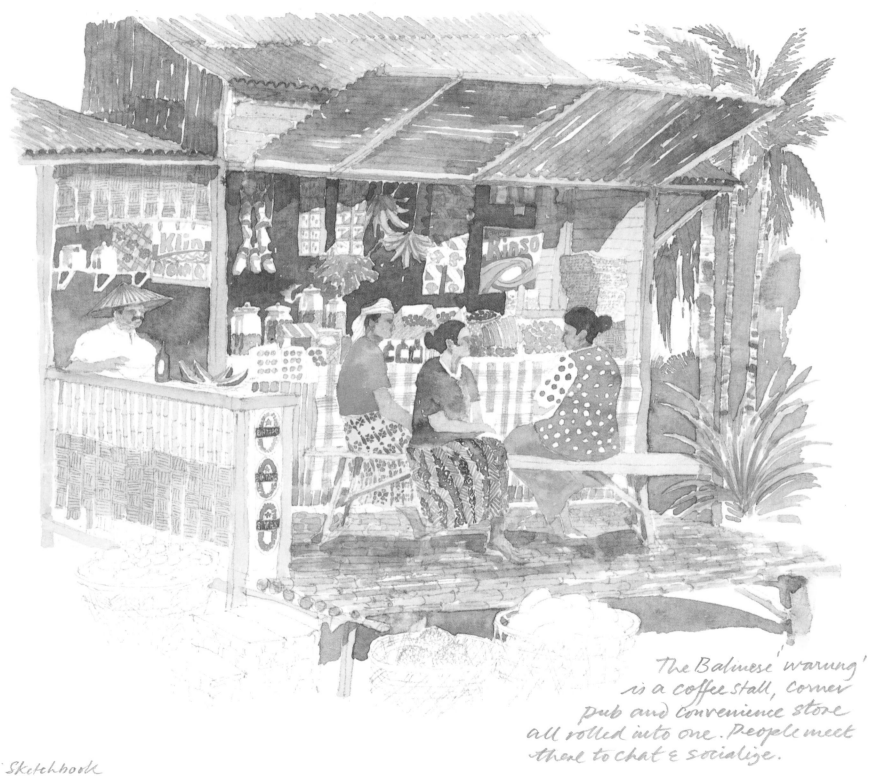

The Balinese 'warung'
is a coffee stall, corner
pub and convenience store
all rolled into one. People meet
there to chat & socialize.

48 Bali Sketchbook

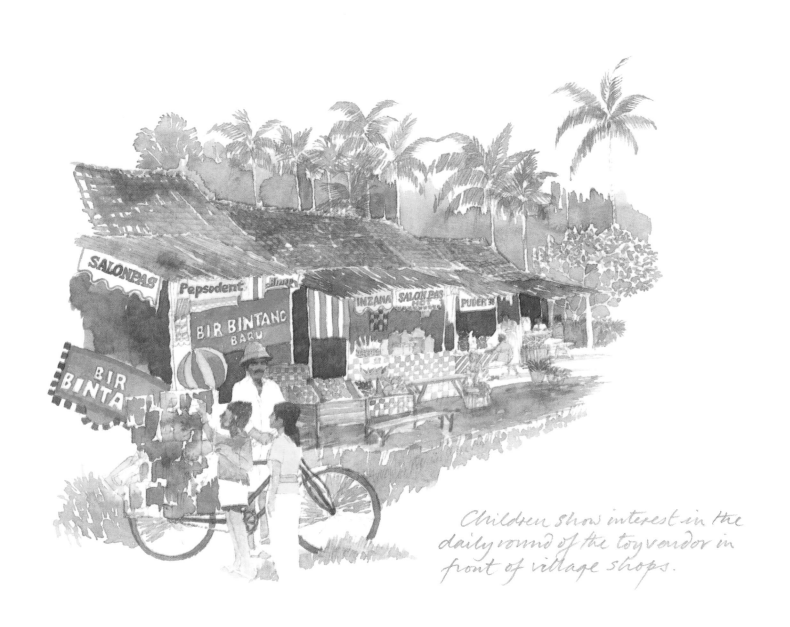

Children show interest in the
daily round of the toy vendor in
front of village shops.

This temple gateway was carved by Gusti Nyoman Lempad, one of Bali's most famous artists who was born in Bedulu.

Swasti Praptika
ring
BR. BATULUMBANG

Neighbourhood sign seen at the entrance to the village.

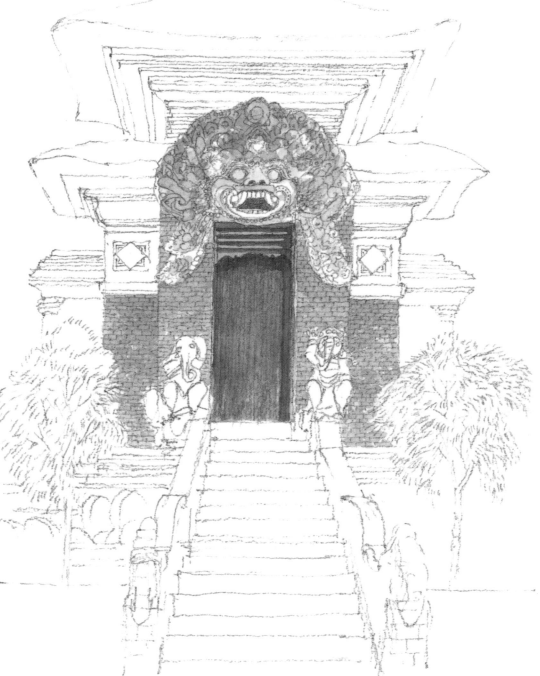

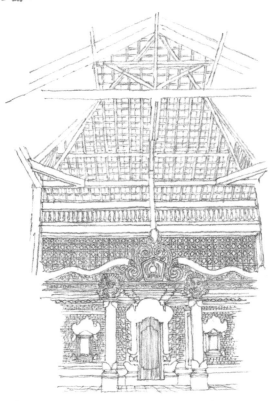

Community hall interior

Notes from Bedulu village

Detail of
"kul kul"
drum tower.

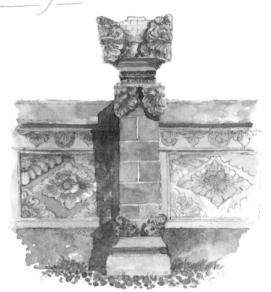

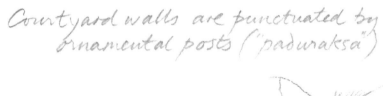

Courtyard walls are punctuated by
ornamental posts ("paduraksa")

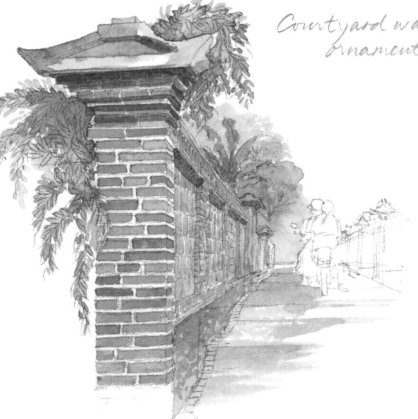

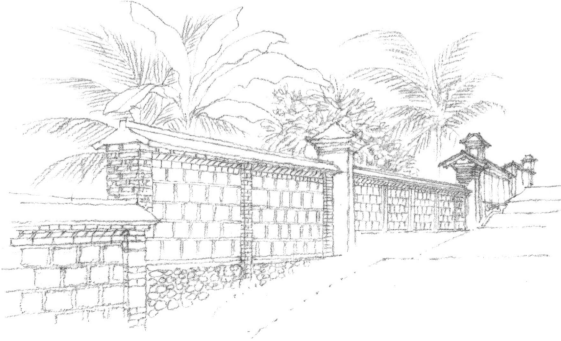

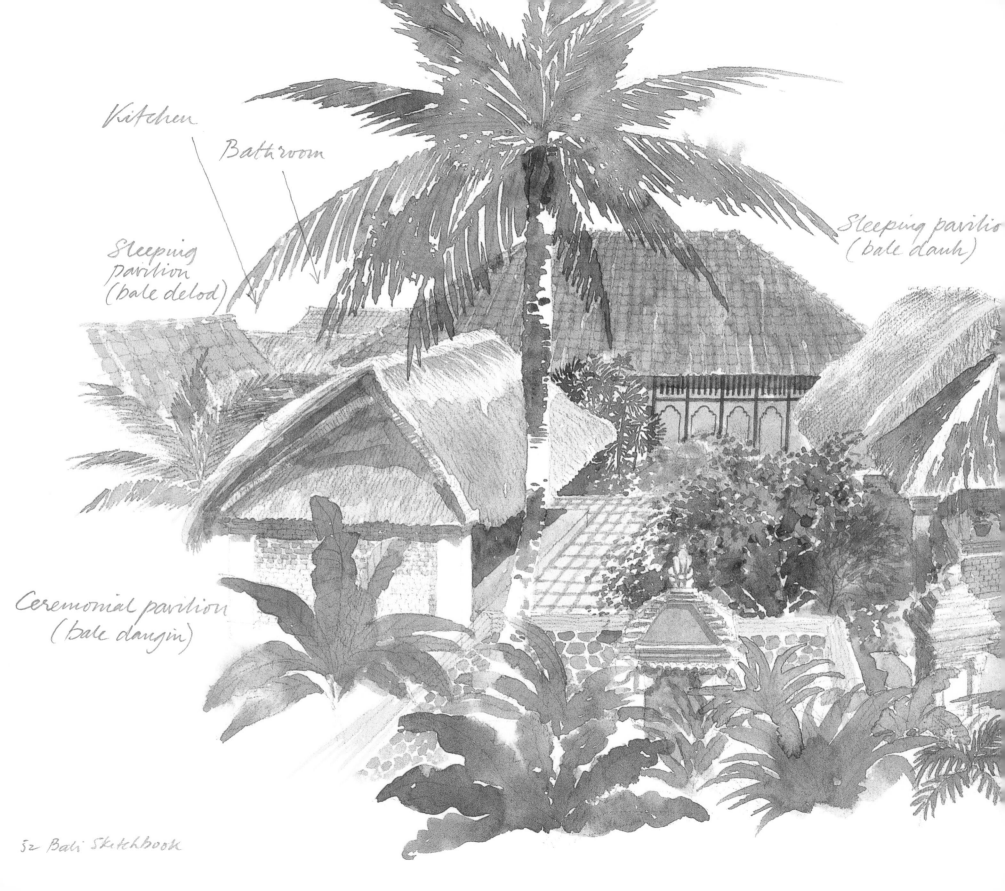

Kitchen

Bathroom

Sleeping pavilion
(bale delod)

Sleeping pavilio
(bale dauh)

Ceremonial pavilion
(bale dangin)

52 Bali Sketchbook

House temple
normally in the
north of the
compound

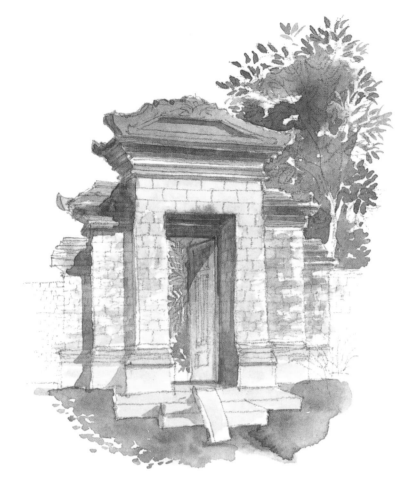

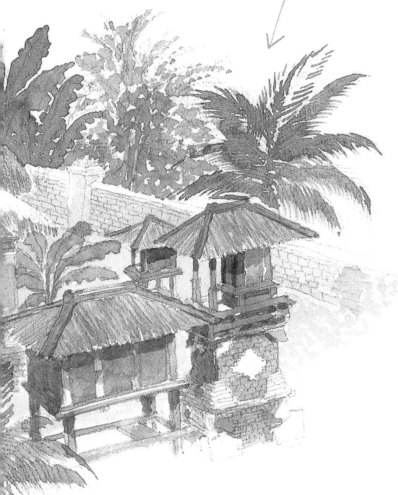

Posted on the house gate of every family compound, is a sign
listing the name of every 'head-of-household' ('kepala
kuluarga'-KK) and the number of males (L) and
females (P) in that nuclear family.

A family house compound, Bedulu village

DSN. BATULUMBANG

NO	NAMA KK	L	P
1	I NYM DARMA	3	2

Fighting cocks are kept in cages of woven bamboo. Ritual cock fights are required in many ceremonies.

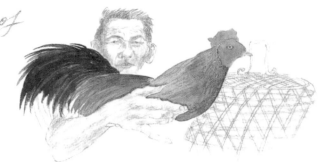

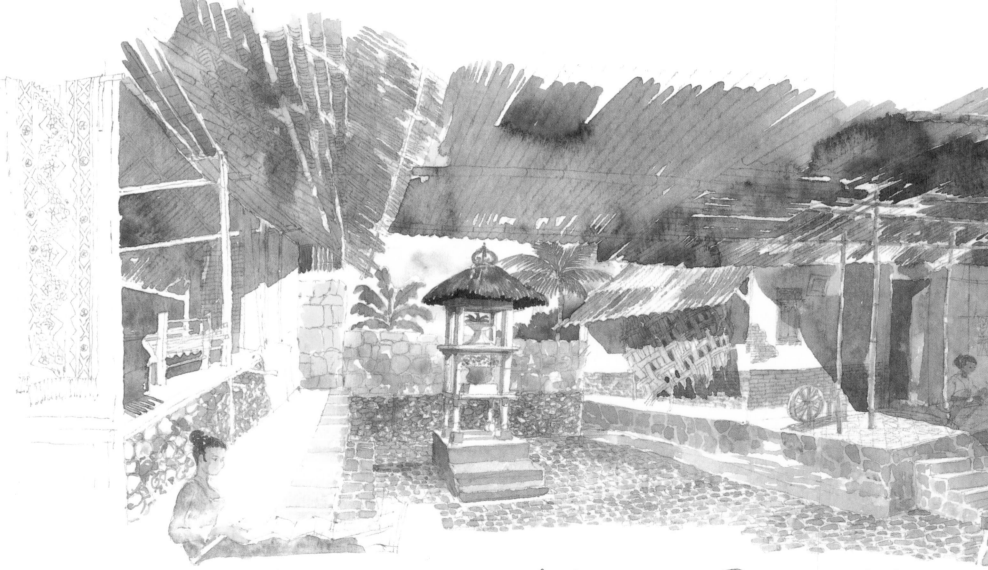

Interior of a Tenganan family compound. The women of the household weave and sell cloth under the eaves.

Scenes from Tenganan village
one of the oldest Bali Aga
villages.

Sacred cows are free to wander
the streets. Very unusual in Bali.

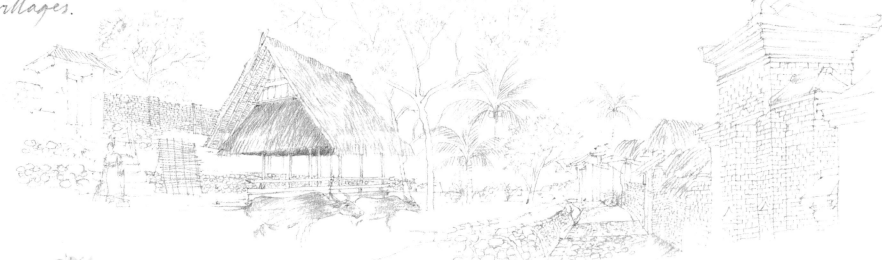

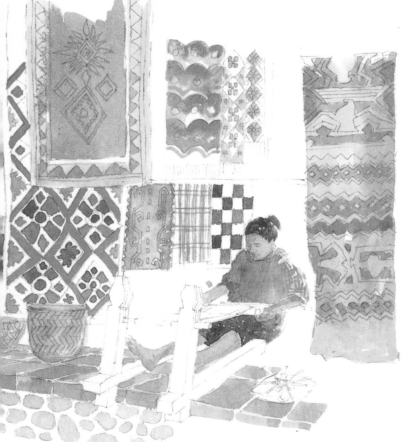

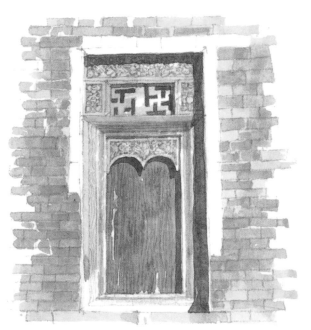

A study of a delicately carved window.

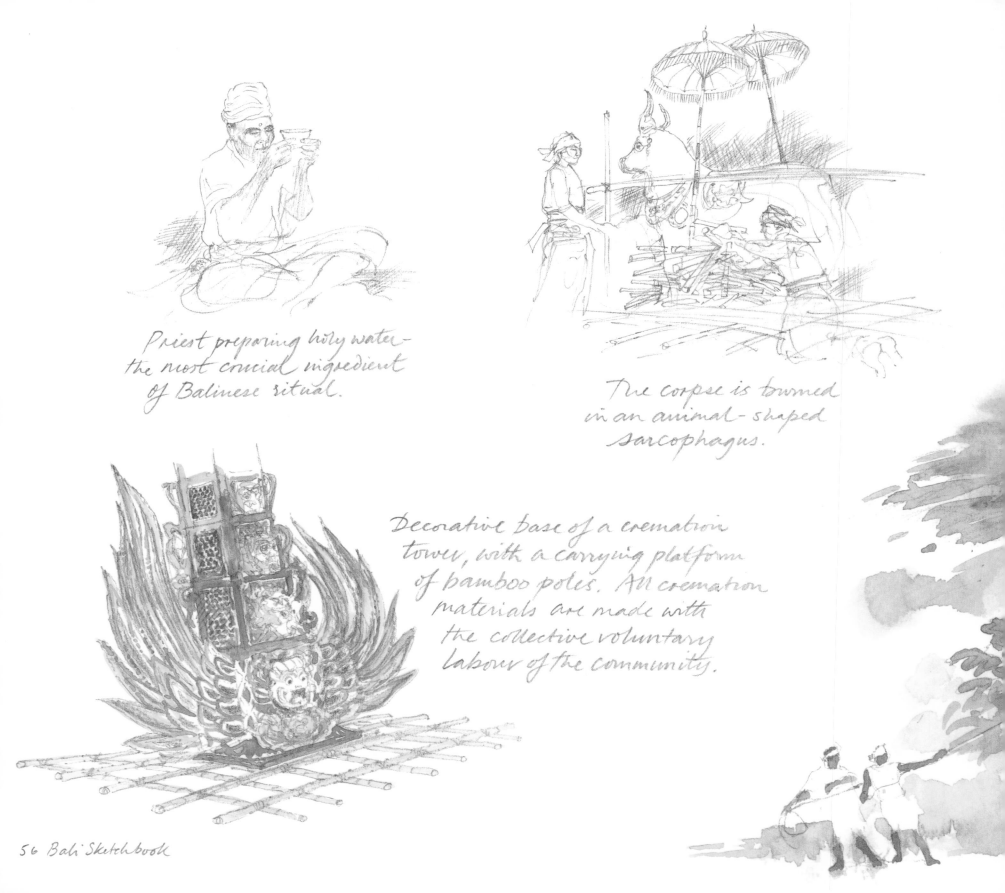

Priest preparing holy water—
the most crucial ingredient
of Balinese ritual.

The corpse is burned
in an animal-shaped
sarcophagus.

Decorative base of a cremation
tower, with a carrying platform
of bamboo poles. All cremation
materials are made with
the collective voluntary
labour of the community.

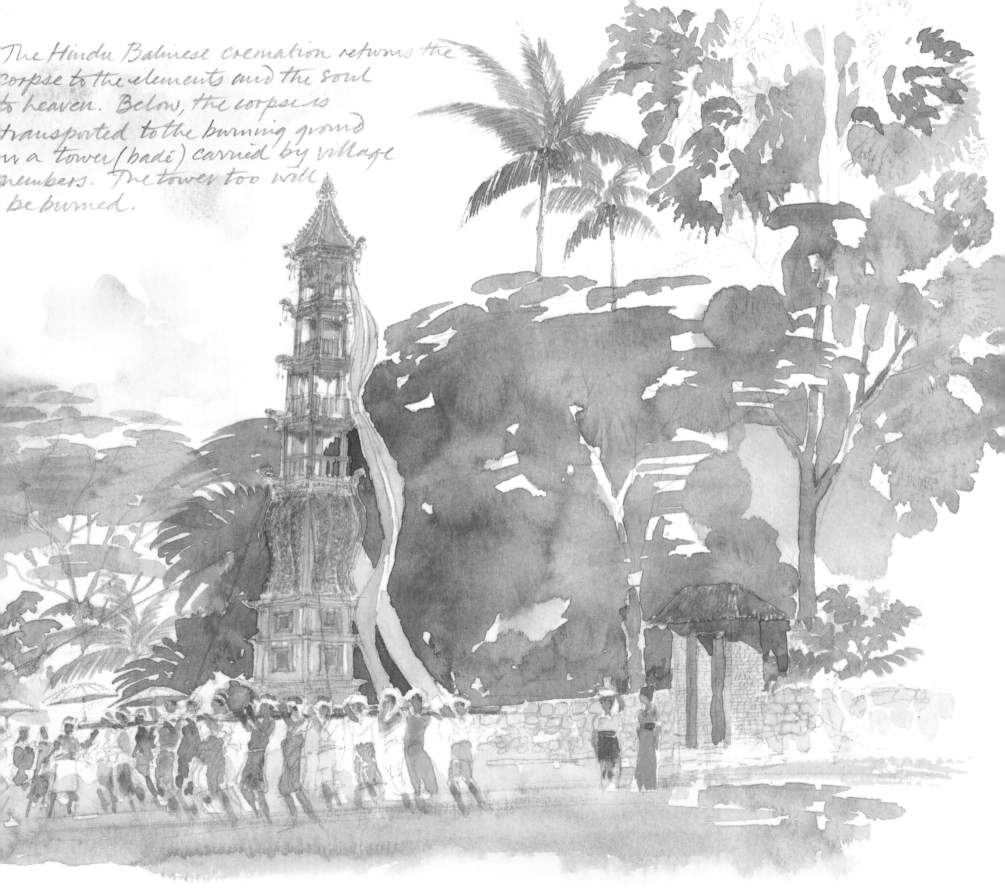

The Hindu Balinese cremation returns the corpse to the elements and the soul to heaven. Below, the corpse is transported to the burning ground in a tower (badé) carried by village members. The tower too will be burned.

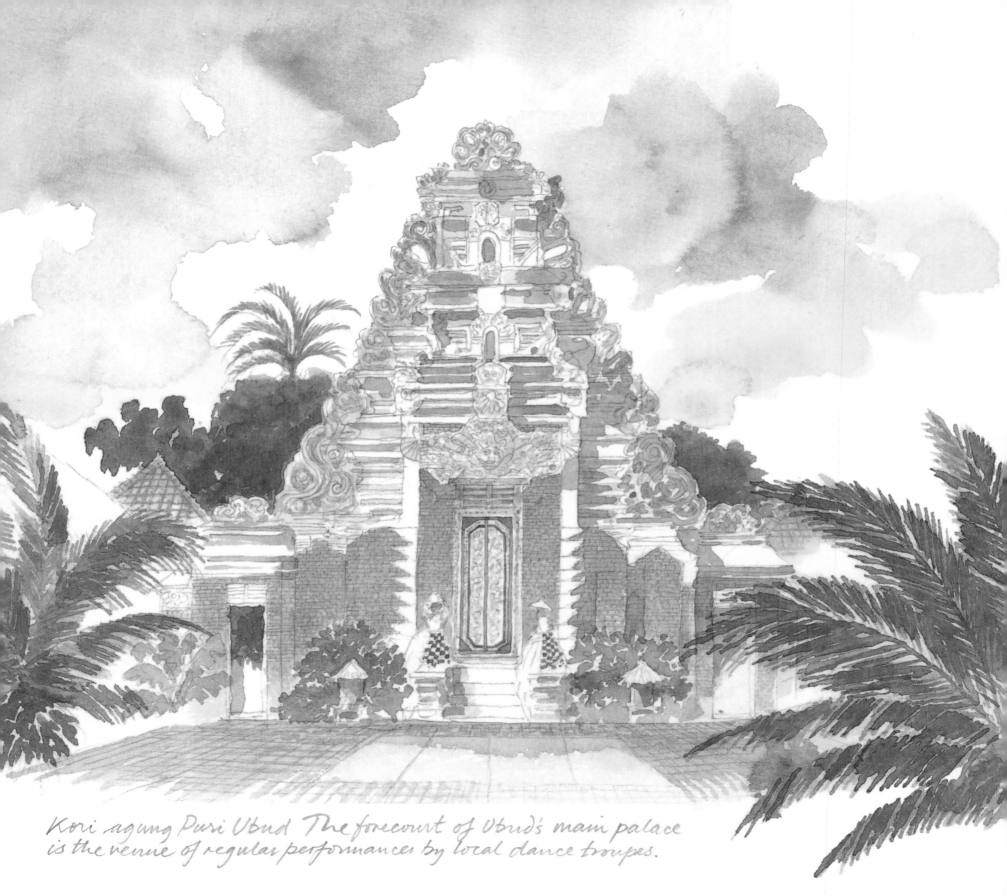

Kori agung Puri Ubud The forecourt of Ubud's main palace is the venue of regular performances by local dance troupes.

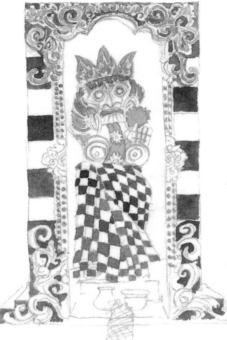

Guardian statues.
Demonic guardian
statue with a black
and white 'poleng'
cloth symbolizing
the balance of
positive and
negative cosmic
forces.

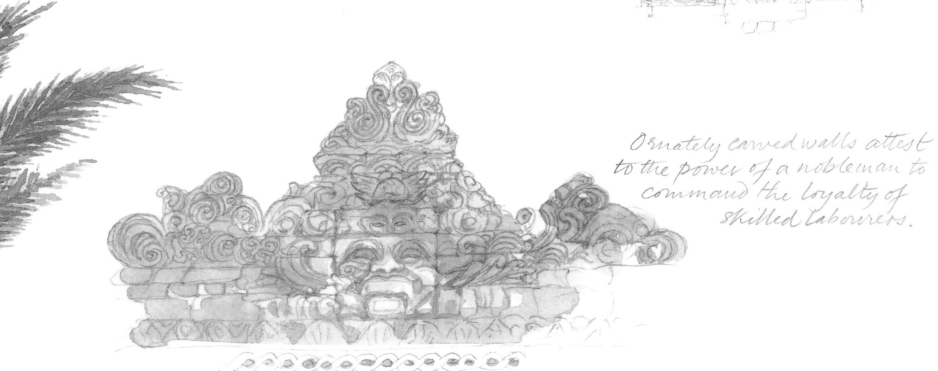

Ornately carved walls attest
to the power of a nobleman to
command the loyalty of
skilled labourers.

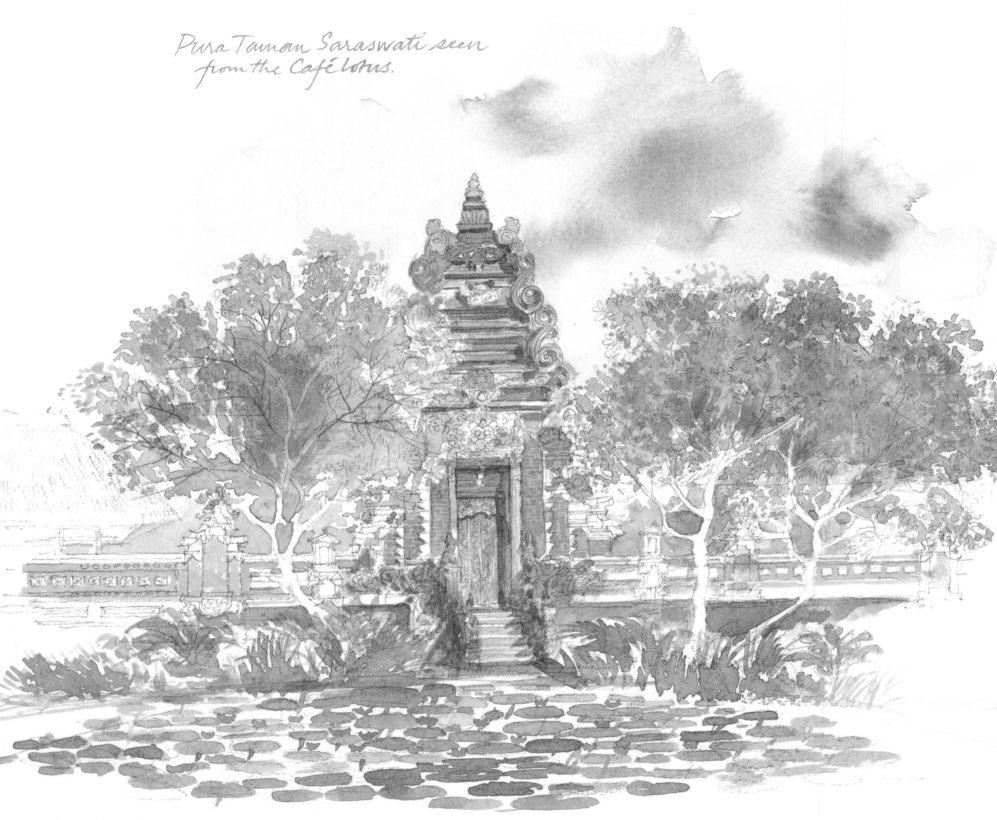

Pura Taman Saraswati seen
from the Café lotus.

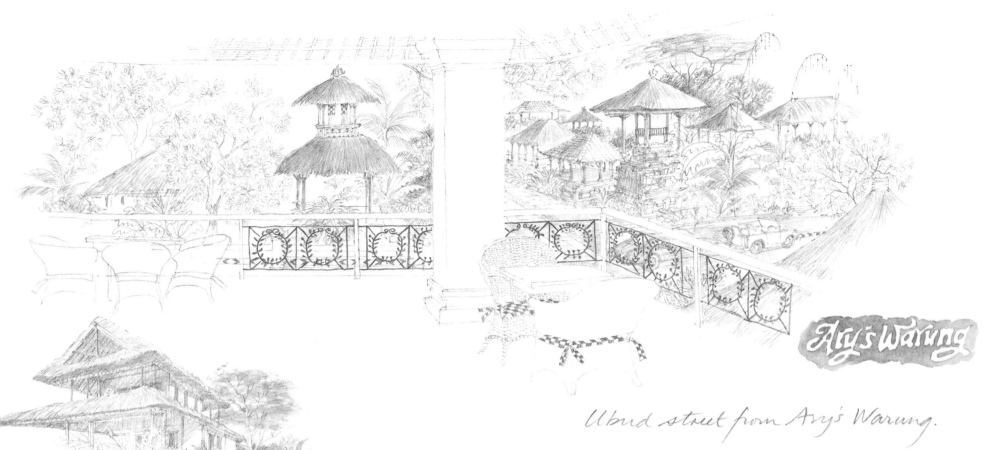

Ary's Warung

Ubud street from Ary's Warung.

German artist Walter Spies's house,
circa 1930, rebuilt as part of Tjampuhan Hotel
(note the Dutch spelling).

An old Dutch bridge over the Campuan
gorge, West Ubud, where two rivers meet – "Campuh"
means "meeting, mixing."

Café Lotus looks out onto the Lotus pond
and the Pura Taman Saraswati

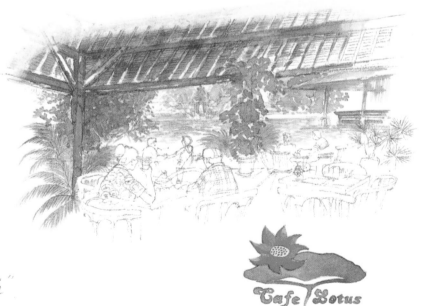

Café Lotus

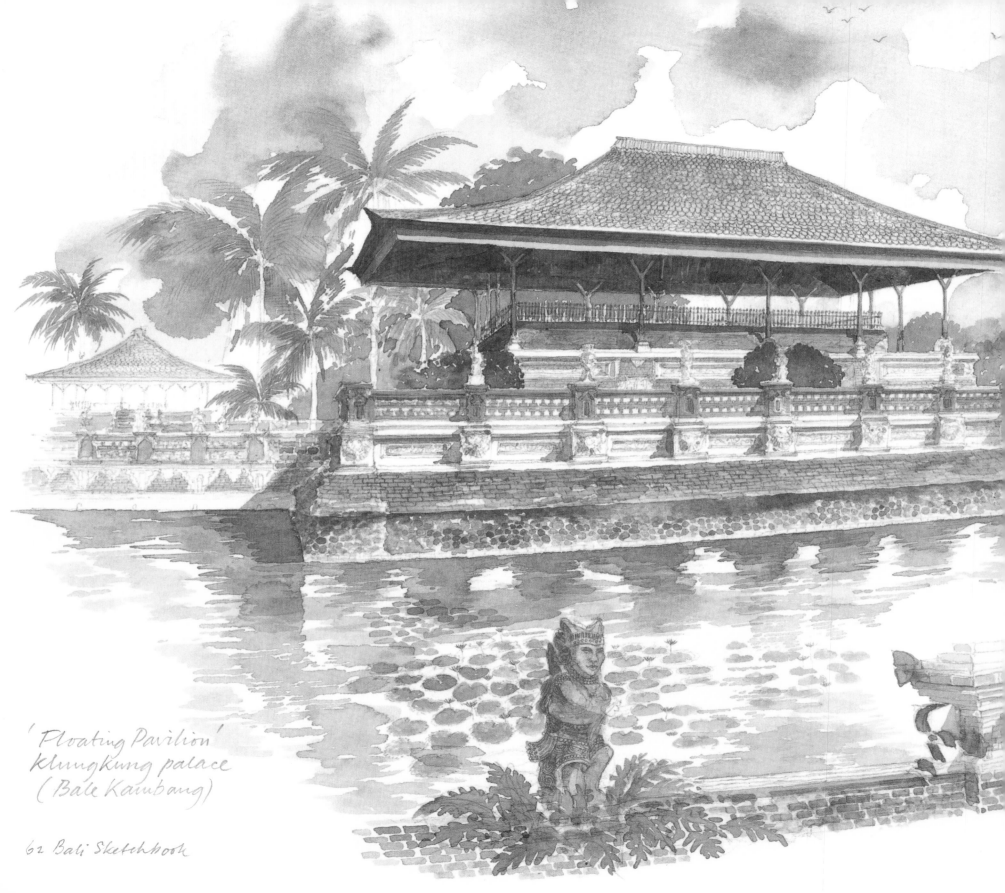

'Floating Pavilion'
klungkung palace
(Bale Kambang)

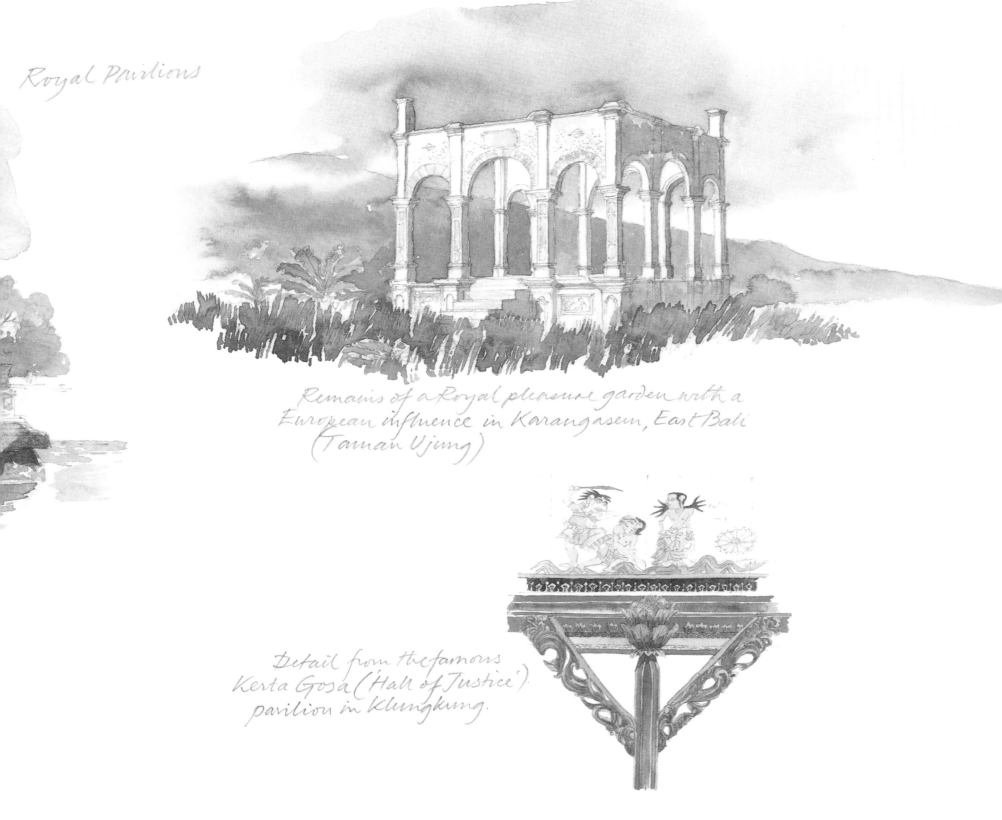

Royal Pavilions

Remains of a Royal pleasure garden with a
European influence in Karangasem, East Bali
(Taman Ujung)

Detail from the famous
Kerta Gosa ('Hall of Justice')
pavilion in Klungkung.

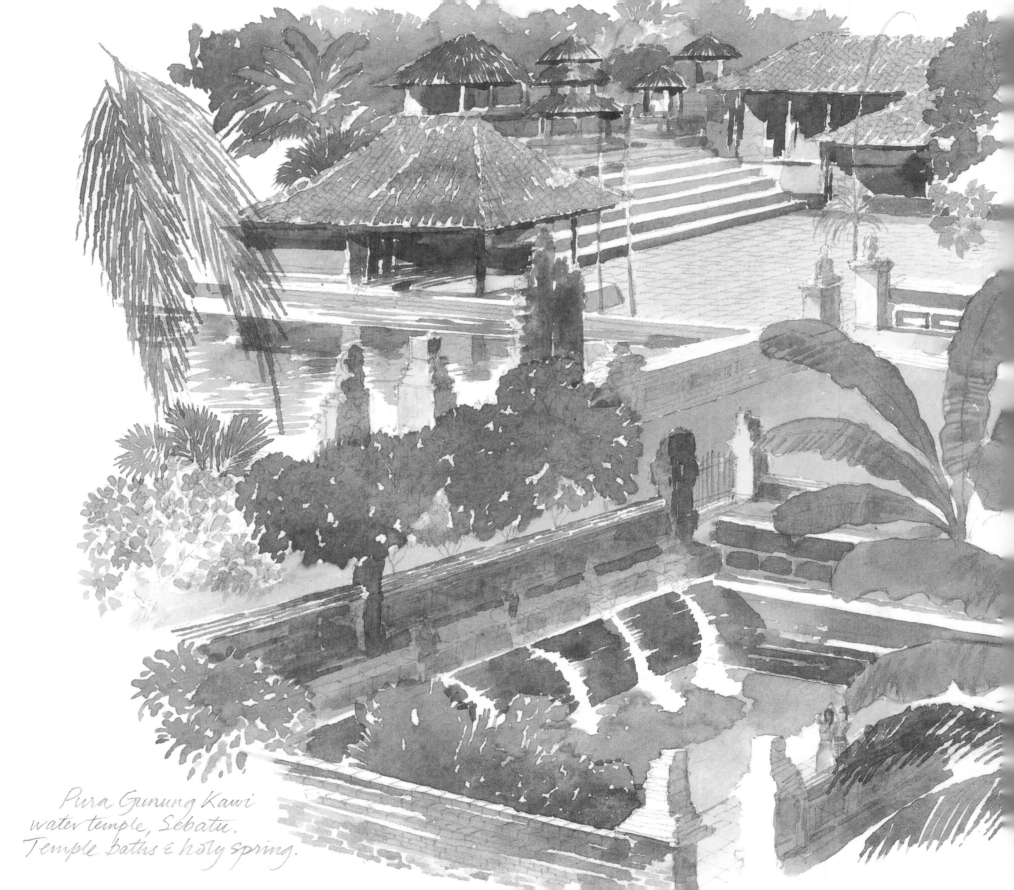

Pura Gunung Kawi
water temple, Sebatu.
Temple baths & holy spring.

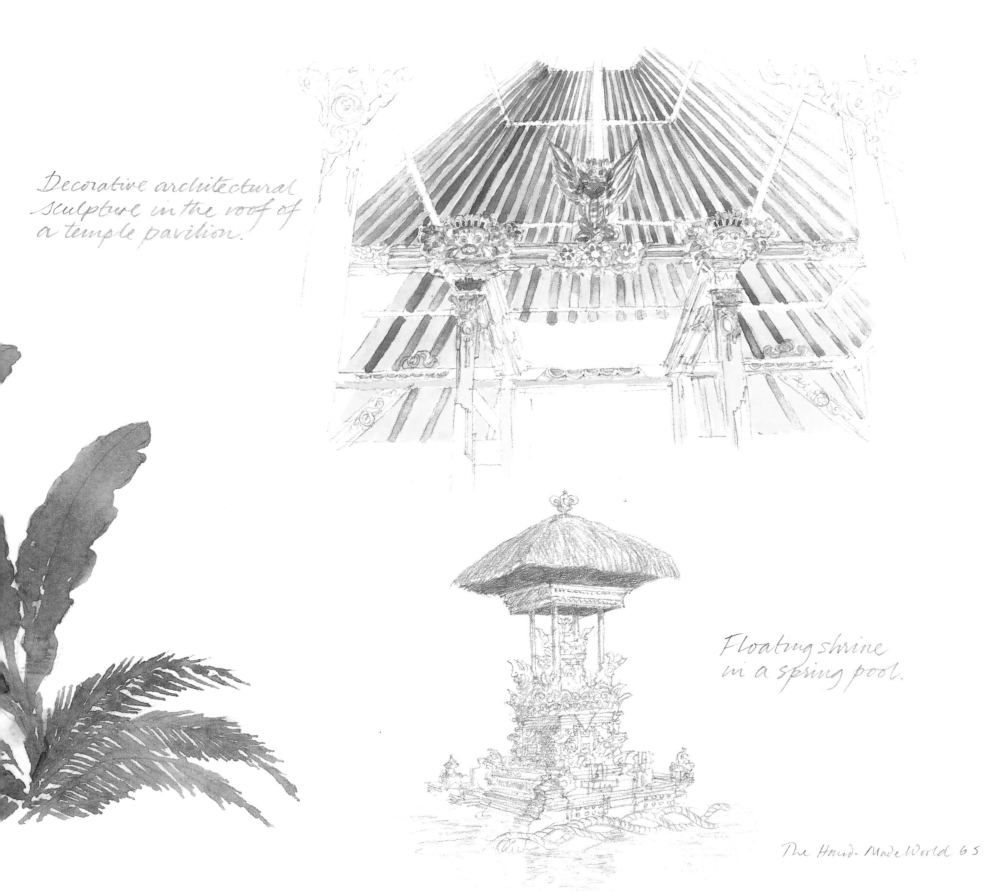

Decorative architectural
sculpture in the roof of
a temple pavilion.

Floating shrine
in a spring pool.

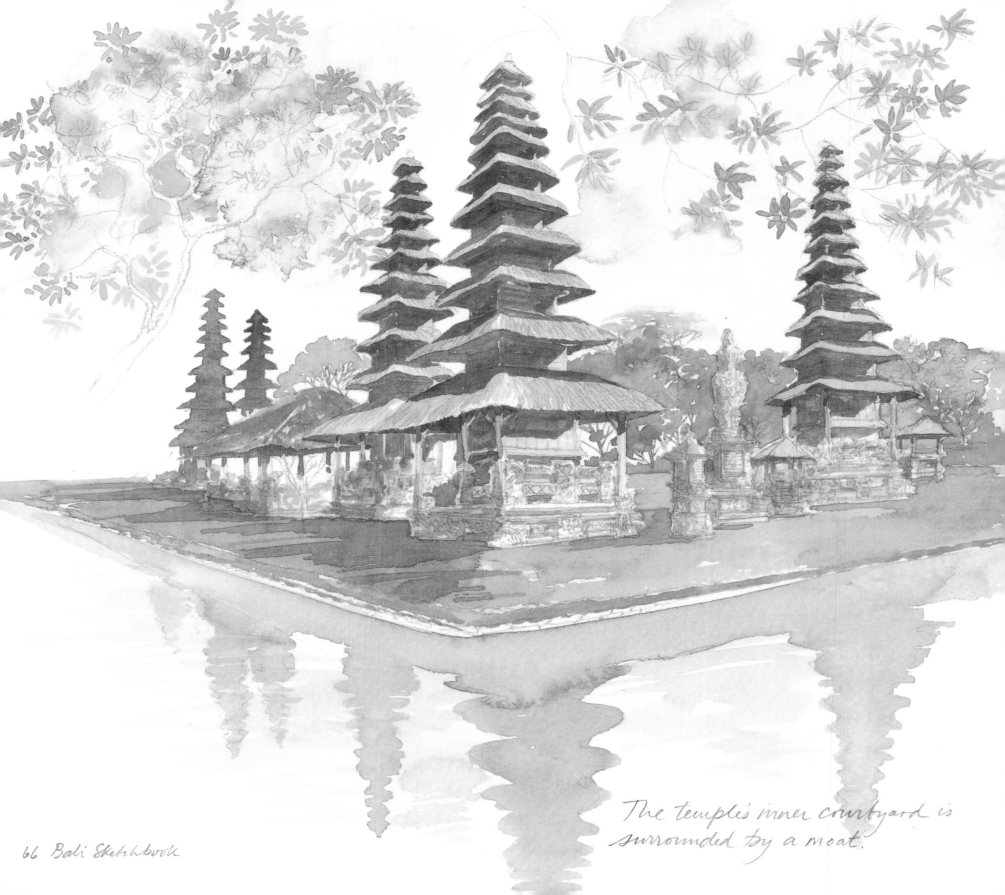

The temple's inner courtyard is
surrounded by a moat.

66 Bali Sketchbook

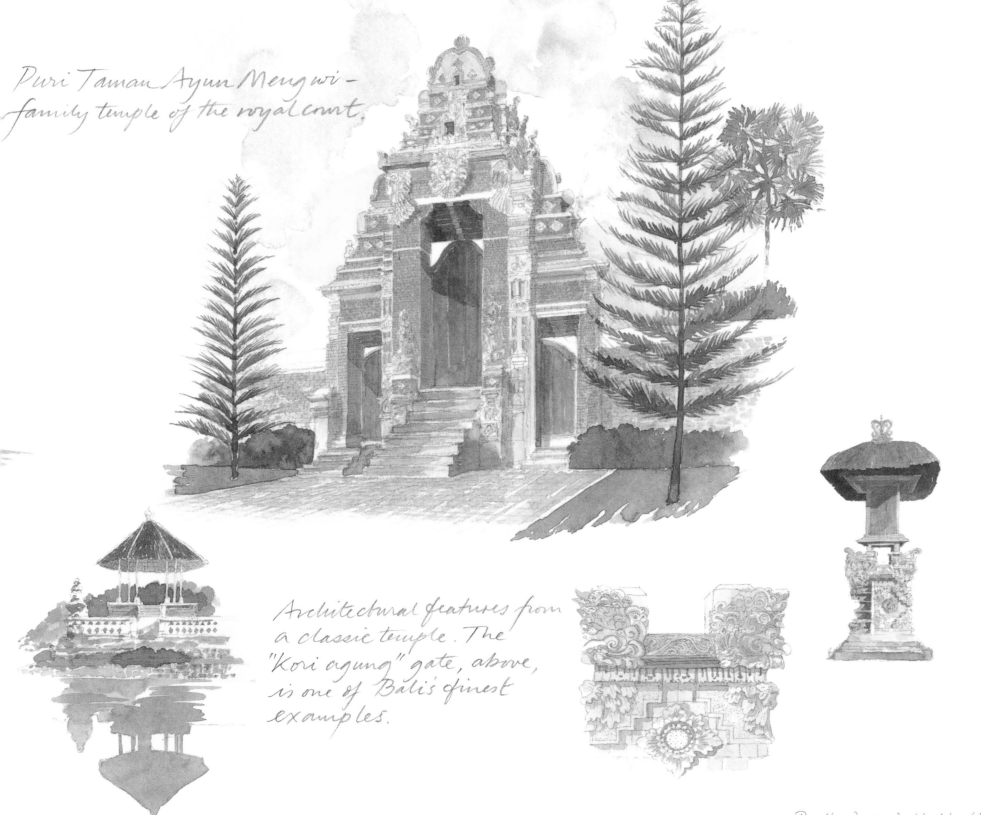

Puri Taman Ayun Mengwi –
family temple of the royal court.

Architectural features from
a classic temple. The
"Kori agung" gate, above,
is one of Bali's finest
examples.

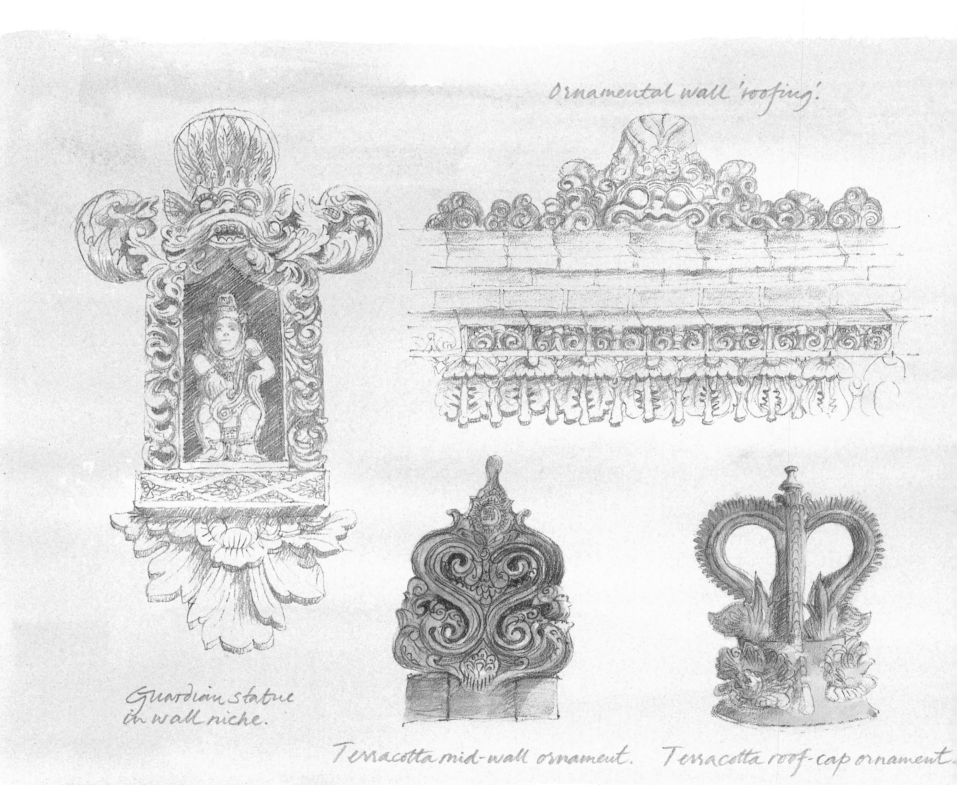

Ornamental wall 'roofing'.

Guardian statue
in wall niche.

Terracotta mid-wall ornament. Terracotta roof-cap ornament.

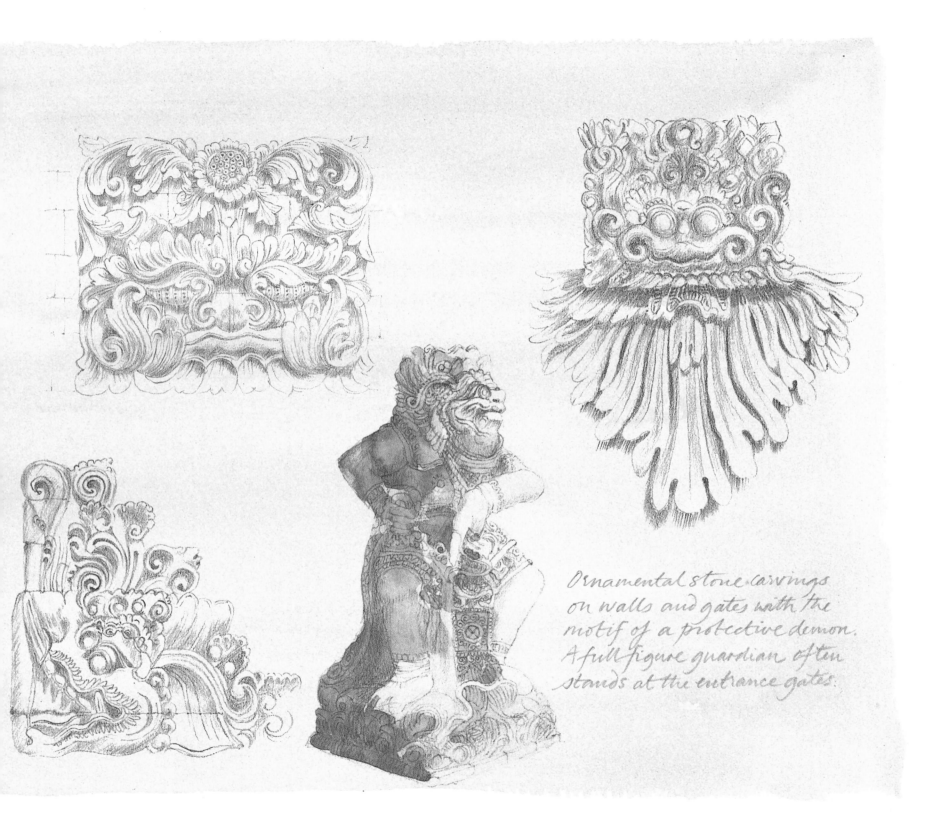

Ornamental stone carvings
on walls and gates with the
motif of a protective demon.
A full figure guardian often
stands at the entrance gates.

Part Three
The Sea Coast. The Edge – the Future

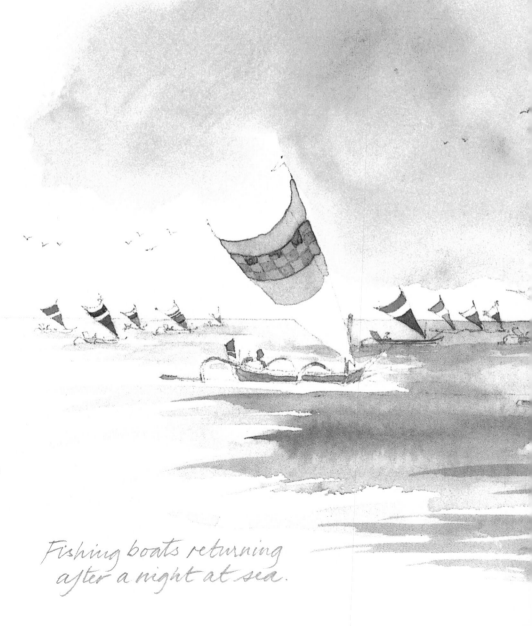

The coast is where Bali digests change. Here urban centres have sprouted in administrative towns and tourism hubs. But parts of the island are relatively isolated from the development boom. On the arid eastern and northwest coasts, subsistence gardens and domestic livestock supplement a livelihood based on salt-making and fishing.

The northern port town of Singaraja (pages 74–77) was Bali's capital from colonial times until 1960 when it was moved to Denpasar (pages 78–81). The decision of the Dutch to build Bali's first tourist hotel (page 78) in this provincial market town puzzled travellers of the 1930s, who politely looked in at the ethnographic Bali Museum (page 80) but preferred to go native in Ubud or to stay at the beach.

A few chose the quiet lagoon of Sanur; others the wild surf of Kuta. The different styles of tourism that grew are remarkably like the seas of each place. Sanur (pages 82–85) remains sedate; Kuta (pages 89–91) is infamously lively. (Ubud is still an enclave of foreign would-be-Balinese.) As in the 1930s, a sub-population of expatriates is comfortably ensconced between the tourists and the local people, and exerts an influence on trends of tourism development (pages 88–89, 90–91). Officialdom chose a 5-star brand of cultural tourism, where culture is offered in fabulous architectural quotations (pages 86–87).

As for the Balinese people, they still honour the edge in coastal temples (pages 92–95) where land and sea converge with the populous air.

Fishing boats returning after a night at sea.

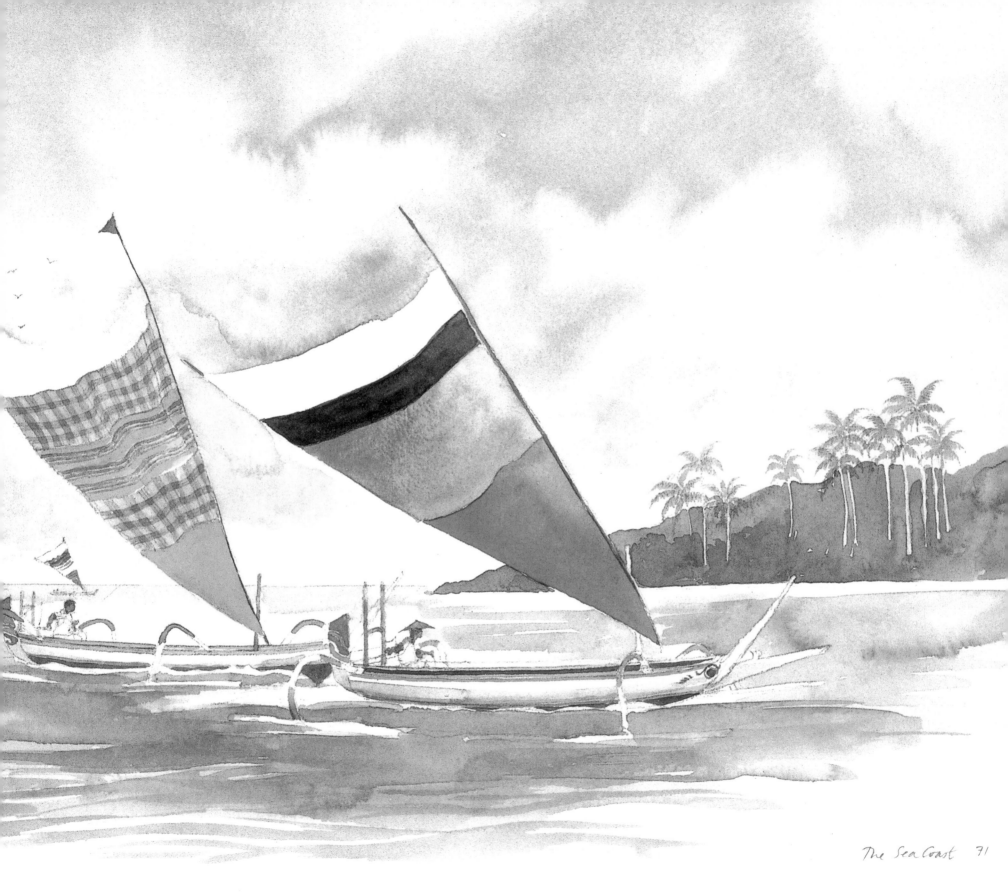

The Sea Coast 71

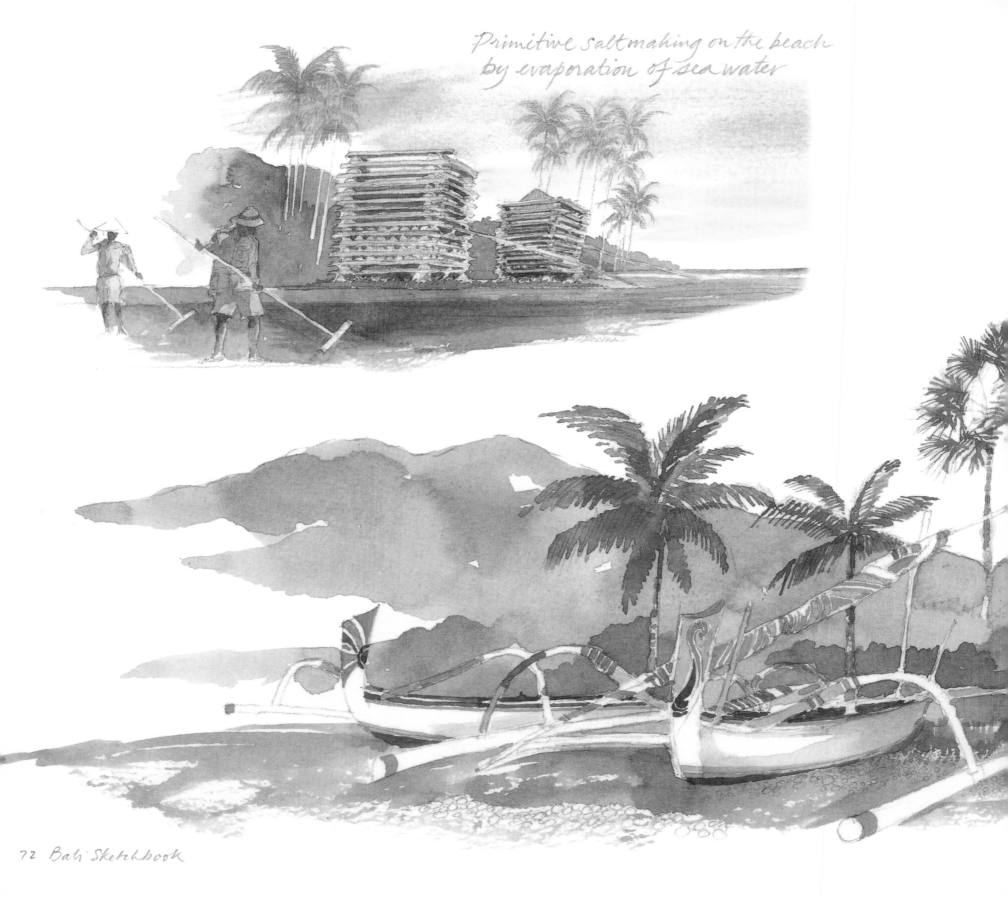

Primitive salt making on the beach
by evaporation of sea water

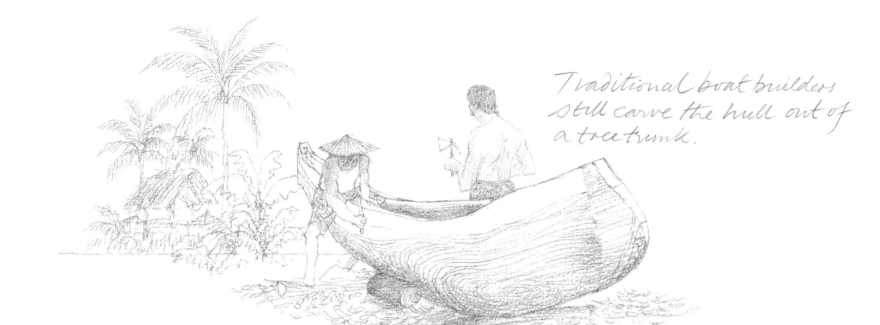

Traditional boat builders still carve the hull out of a tree trunk.

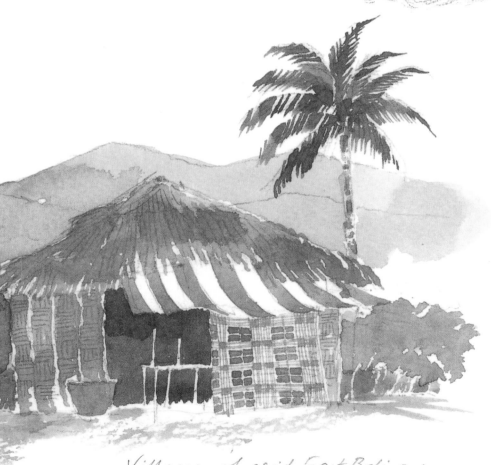

Villagers of arid East Bali are fishermen and small farmers.

Decorative painted details of the stern and bow of an outrigger canoe.

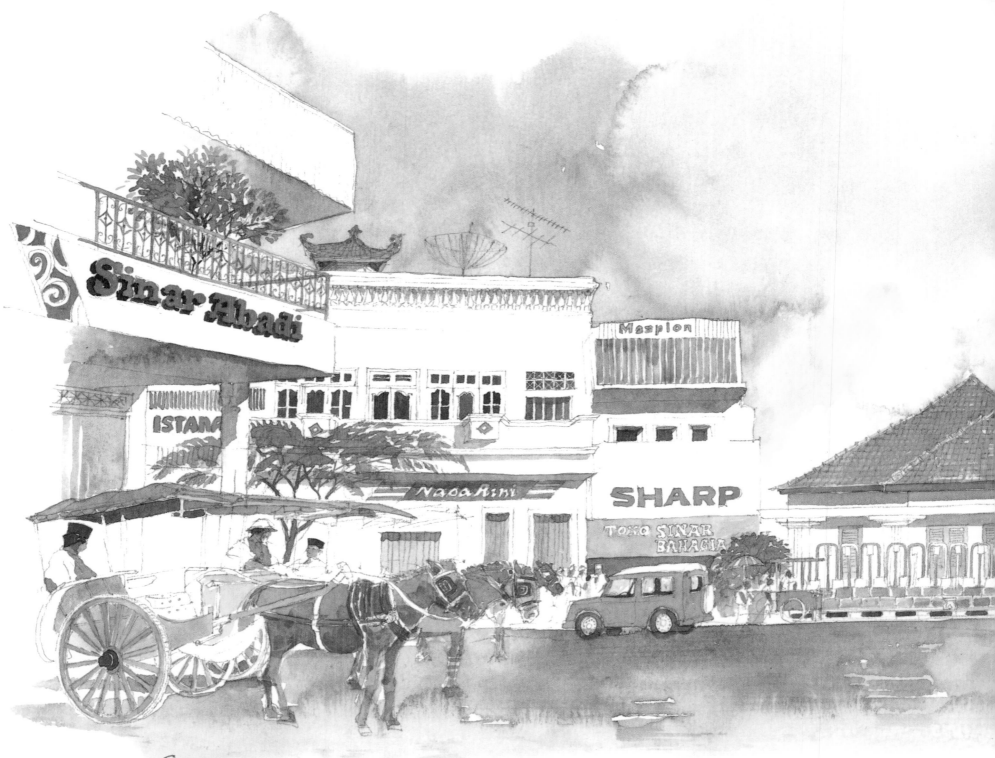

Singaraja – the main town on Bali's North Coast and the former capital
under Dutch rule. Note the small Dutch bungalow built in the 1930s which
has been enveloped by modern Singaraja.

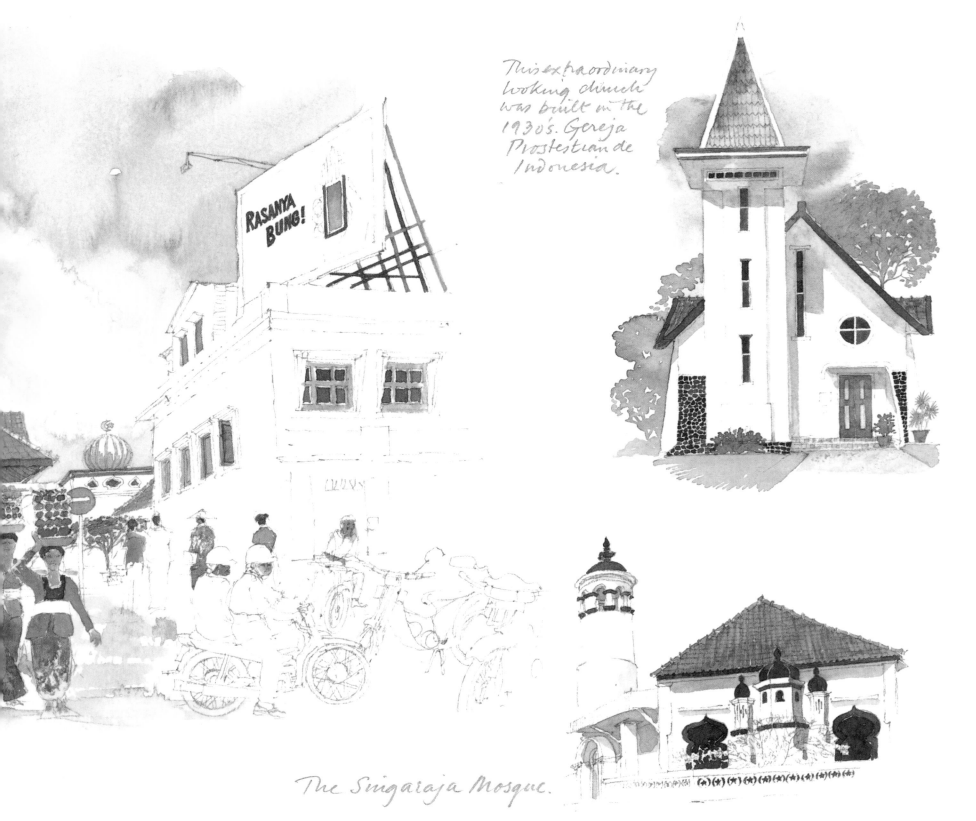

This extraordinary looking church was built in the 1930's. Gereja Proostestian de Indonesia.

RASANYA BUNG!

The Singaraja Mosque.

Dutch traditional bungalow with a Balinese temple design on the front entrance.

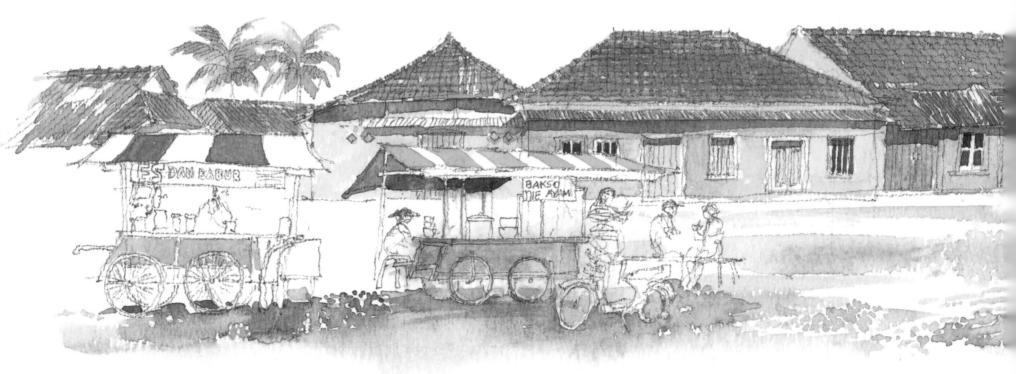

Singaraja's old dockside by the former harbour. Built by the Dutch in the 1920/30s it has many splendid examples of Dutch roofs.

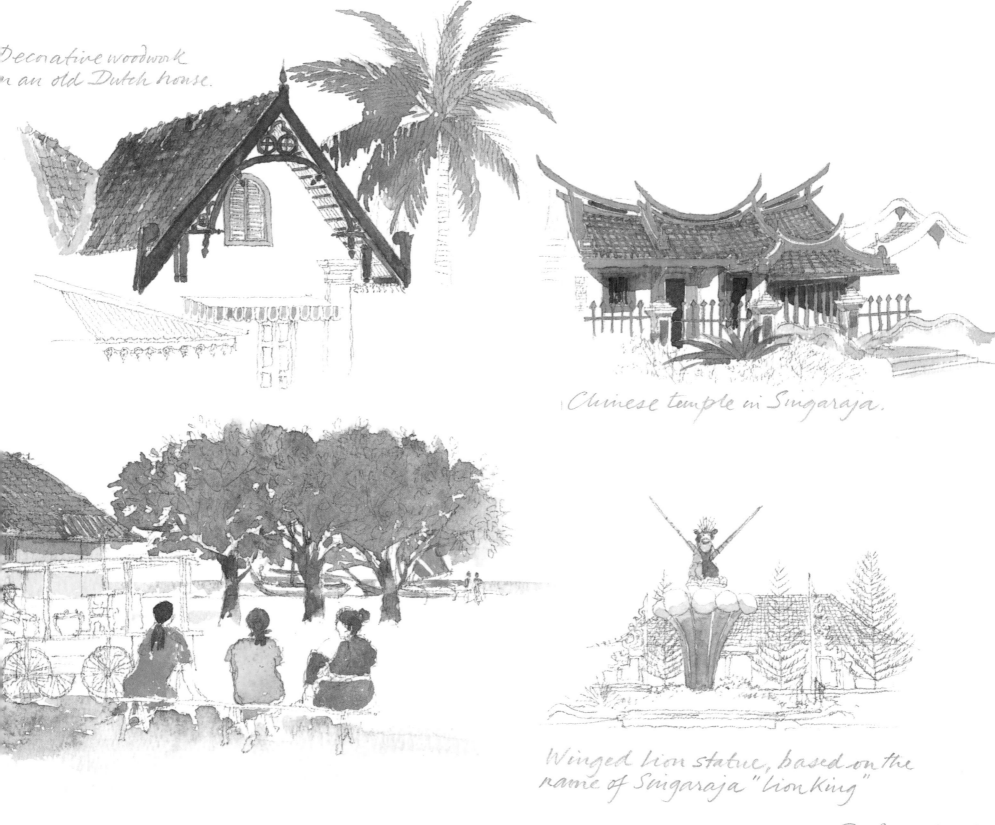

Decorative woodwork
on an old Dutch house.

Chinese temple in Singaraja.

Winged lion statue, based on the
name of Singaraja "Lion King"

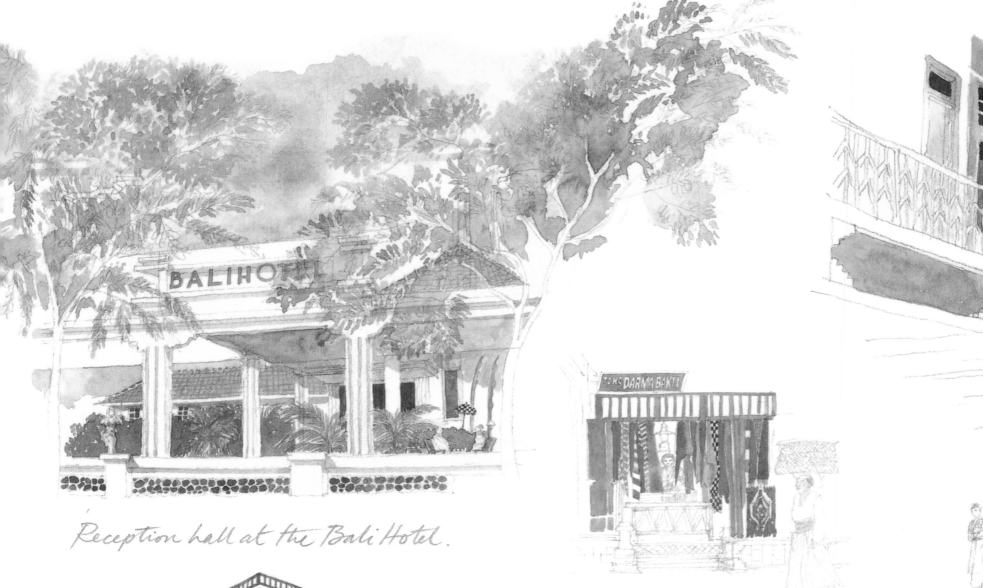

Reception hall at the Bali Hotel.

Textile shops line Jalan Sulawesi, a side street bordering Denpasar's central market. Many of these merchants are of Arab descent.

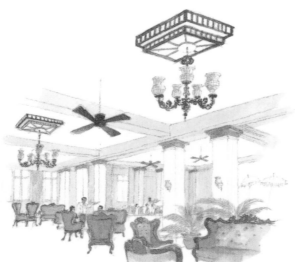

Graphic shop signs adorn Denpasar.

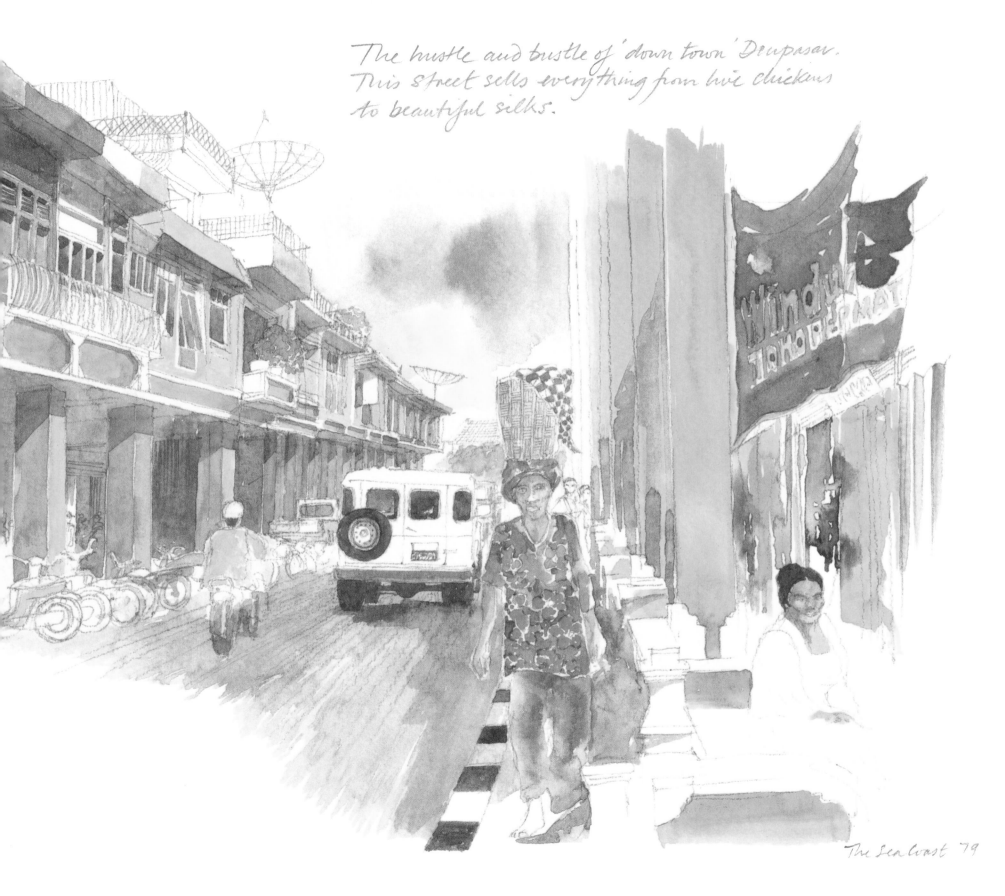

The hustle and bustle of 'down town' Denpasar.
This street sells everything from live chickens
to beautiful silks.

The Sea Coast 79

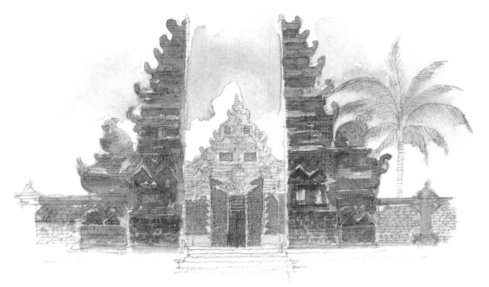

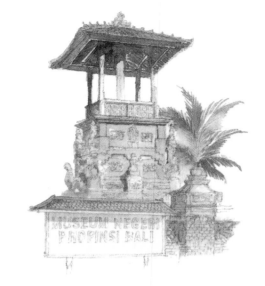

The Bali Museum is a showcase of varieties of regional architectural styles.

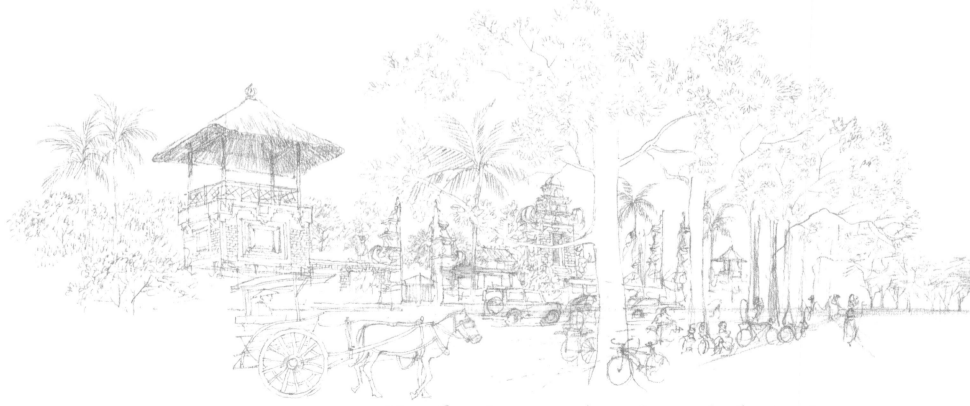

The Bali Museum lies along a leafy street abutting the eastern edge of Puputan Square, Denpasar.

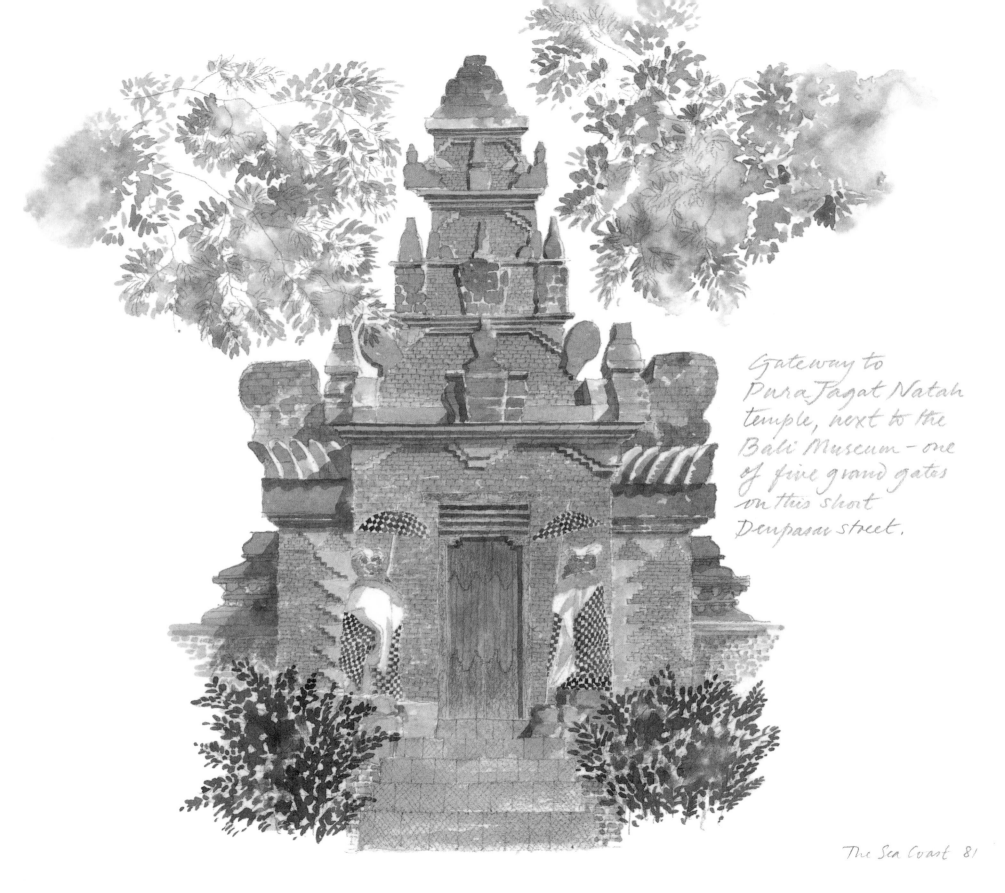

Gateway to
Pura Jagat Natah
temple, next to the
Bali Museum – one
of five grand gates
on this short
Denpasar street.

The Sea Coast 81

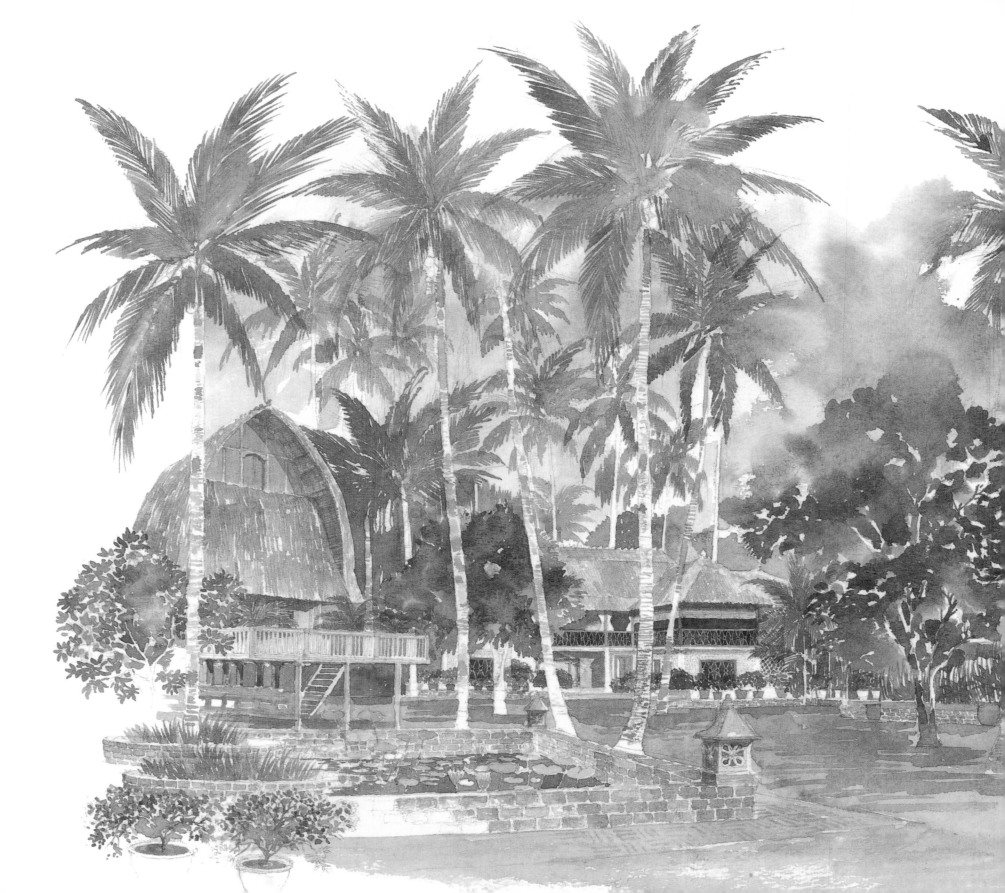

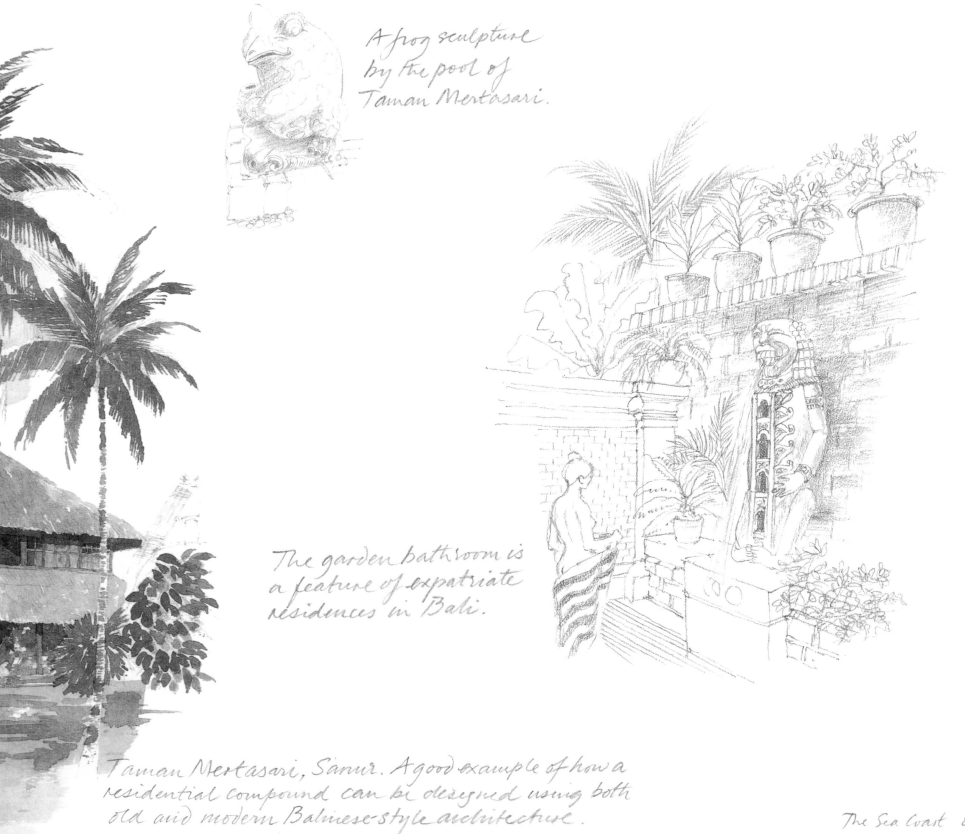

A frog sculpture
by the pool of
Taman Mertasari.

The garden bathroom is
a feature of expatriate
residences in Bali.

Taman Mertasari, Sanur. A good example of how a
residential compound can be designed using both
old and modern Balinese-style architecture.

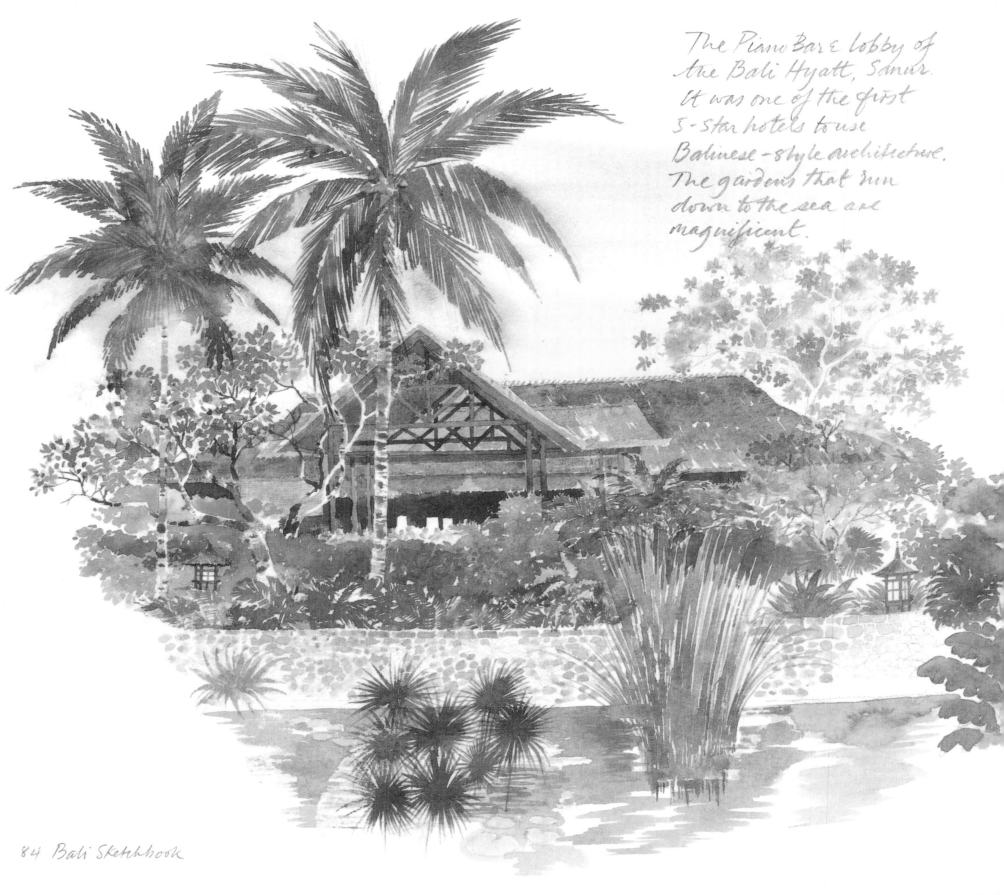

The Piano Bar & lobby of
the Bali Hyatt, Sanur.
It was one of the first
5-Star hotels to use
Balinese-style architecture.
The gardens that run
down to the sea are
magnificent.

La Taverna, Sanur.
The 'four post bale' serves as
a large sitting area and also
as an open library.

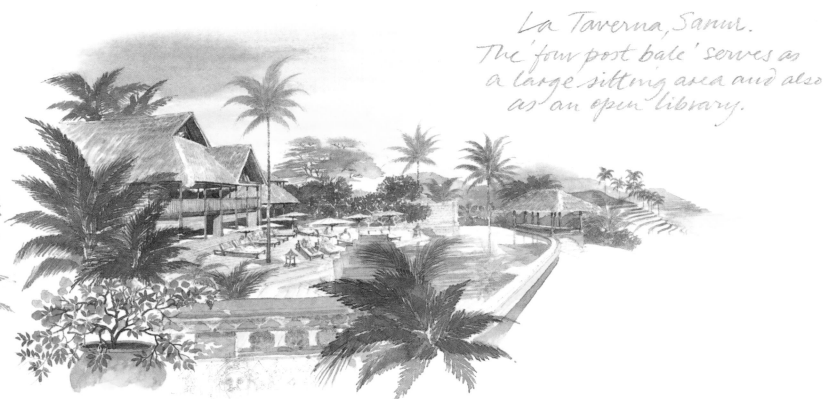

The Amandari, Ubud, which launched a new
trend for discreet hotel architecture. The swimming
pool fits the contours of the land like the adjacent ricefields.

The Sea Coast 85

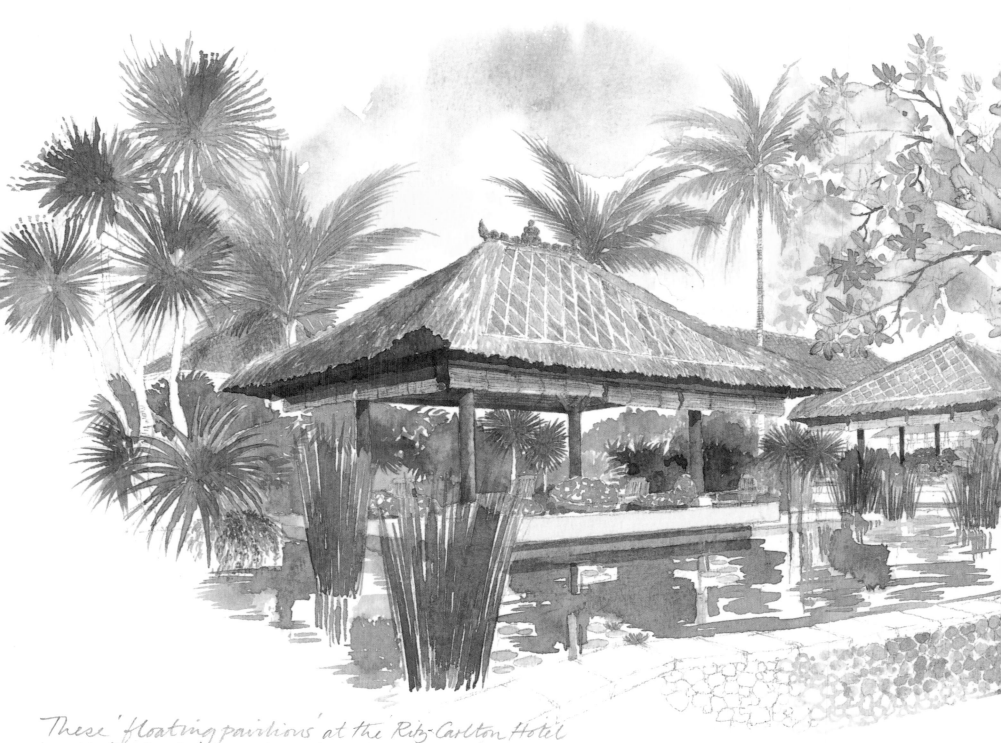

These 'floating pavilions' at the Ritz-Carlton Hotel
recall that of Klungkung's palace and have a
superb view over the sea.

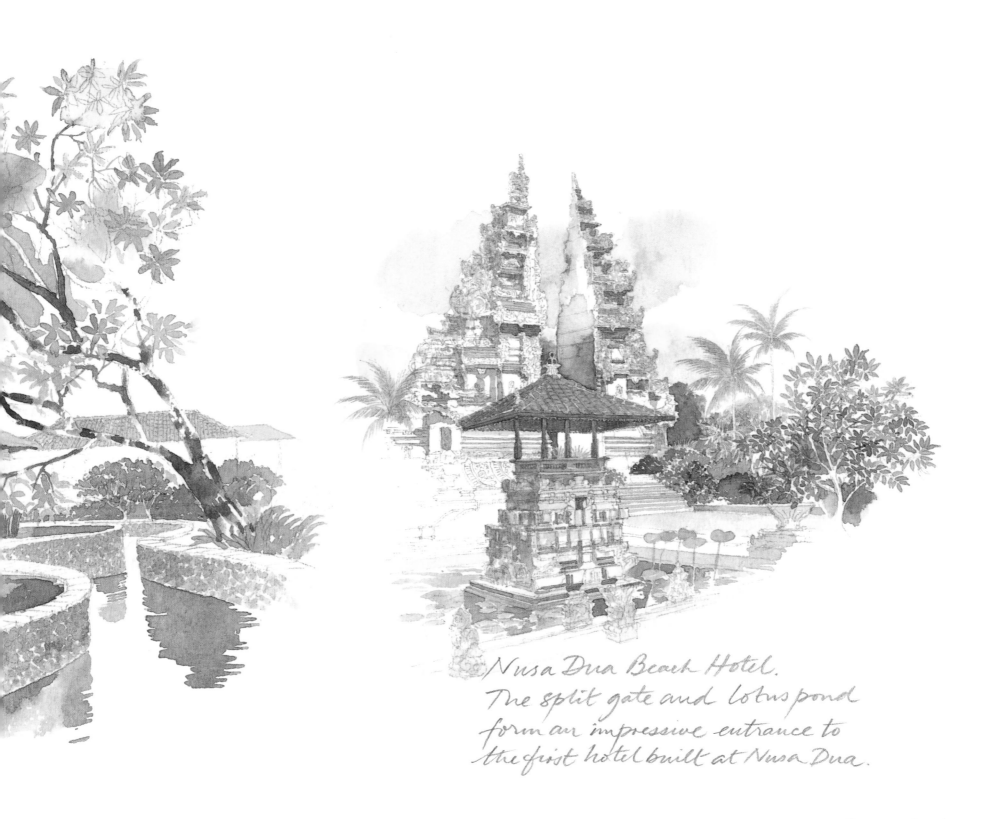

Nusa Dua Beach Hotel.
The split gate and lotus pond
form an impressive entrance to
the first hotel built at Nusa Dua.

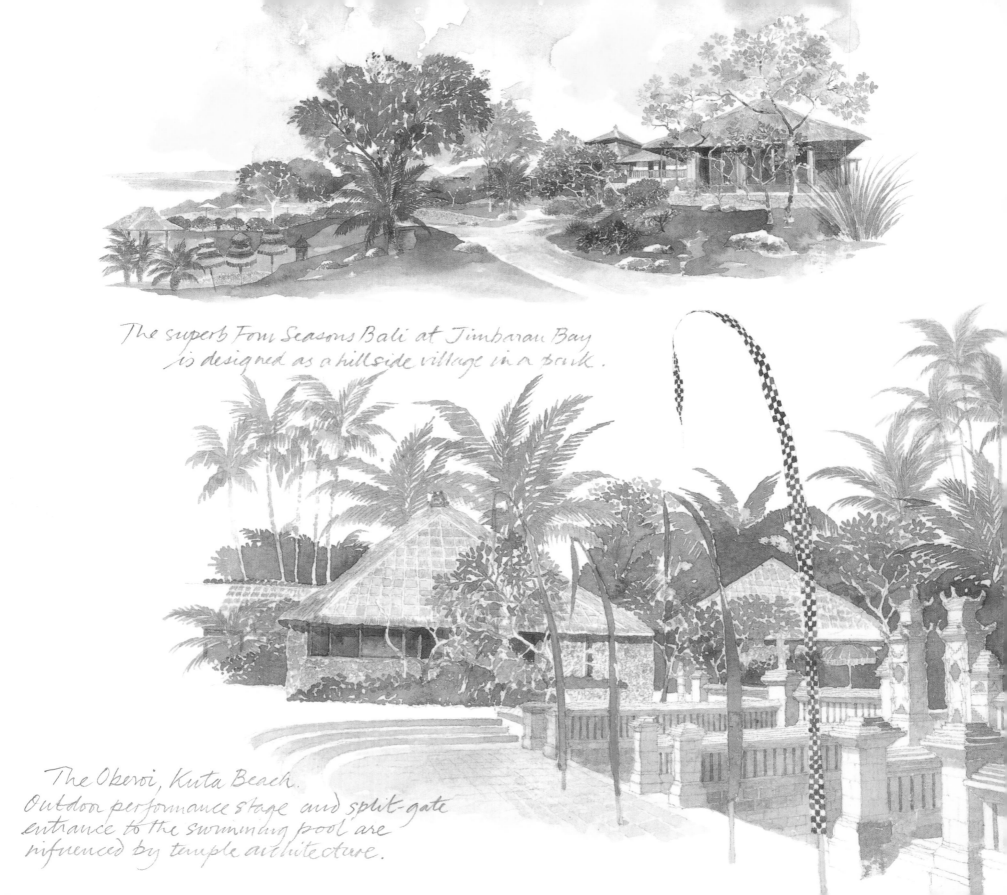

The superb Four Seasons Bali at Jimbaran Bay
is designed as a hillside village in a park.

The Oberoi, Kuta Beach.
Outdoor performance stage and split-gate
entrance to the swimming pool are
influenced by temple architecture.

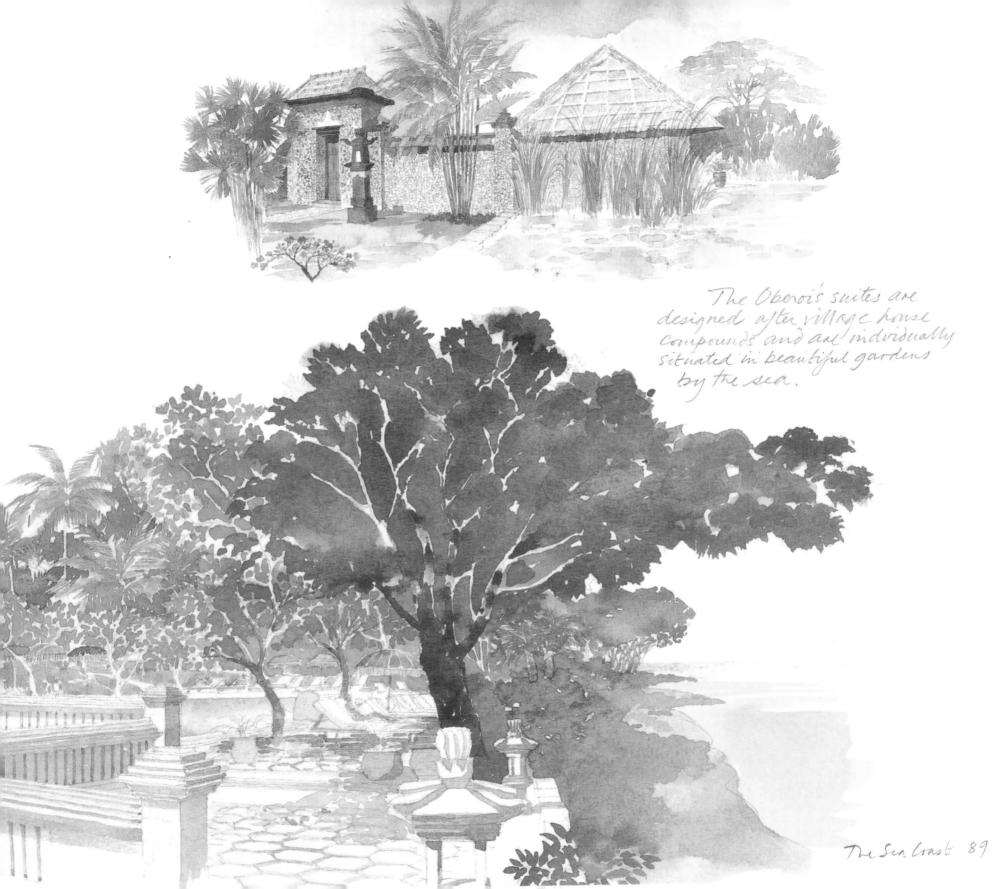

The Oberoi's suites are
designed after village house
compounds and are individually
situated in beautiful gardens
by the sea.

The Sea Coast 89

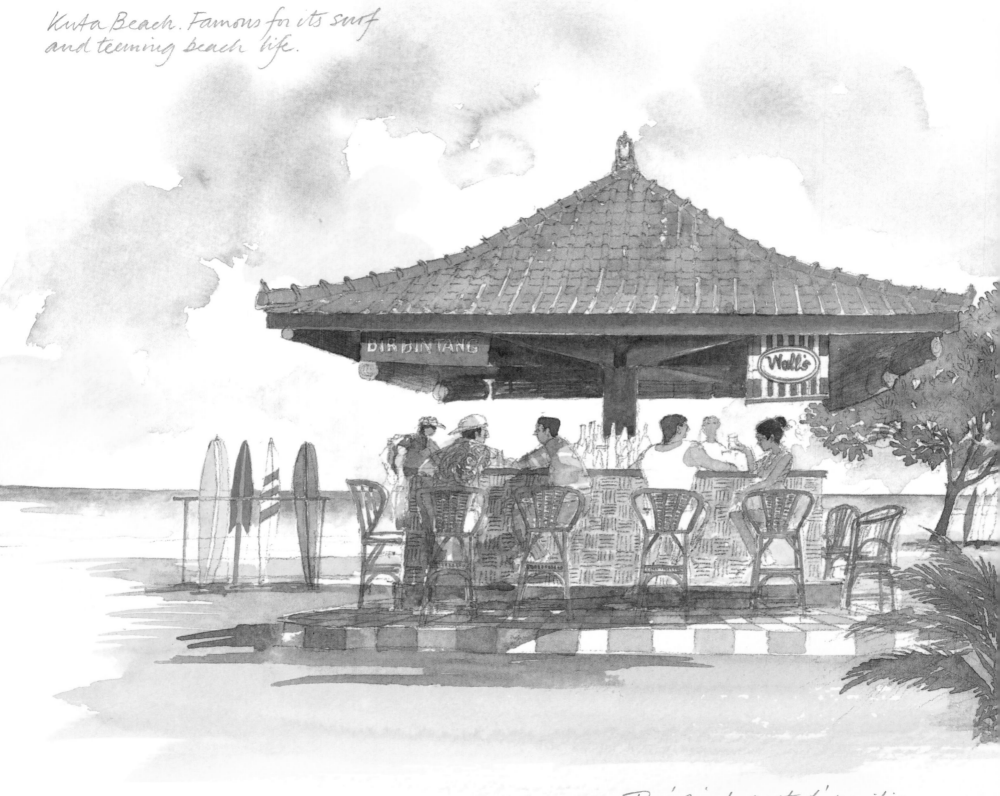

Kuta Beach. Famous for its surf
and teeming beach life.

The 'single posted' pavilion
reinterpreted as a beachside bar.

90 Bali Sketchbook

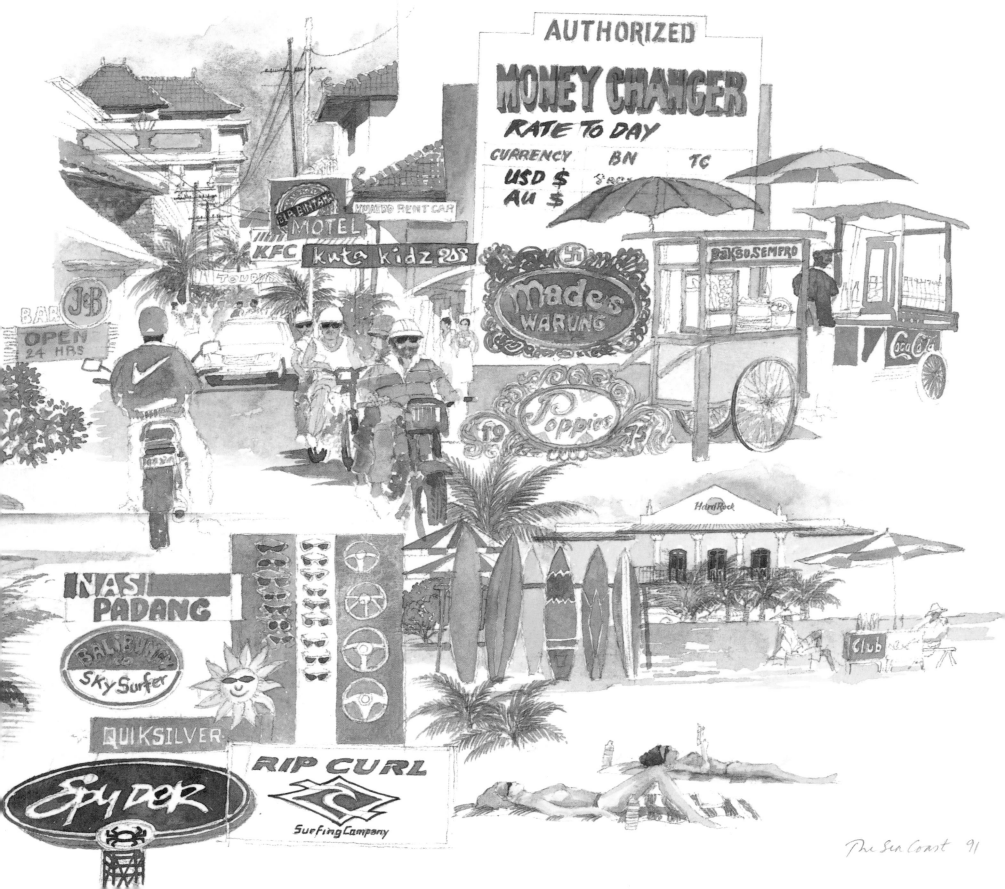

The Sea Coast 91

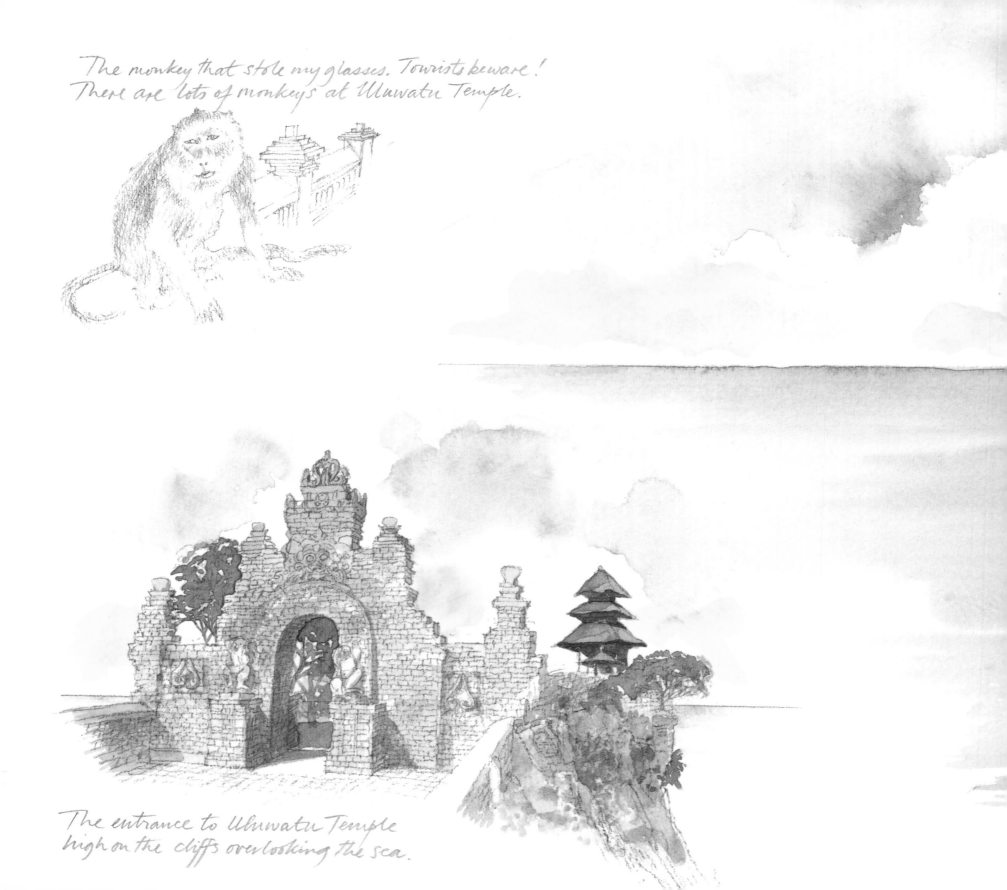

The monkey that stole my glasses. Tourists beware!
There are lots of monkeys at Uluwatu Temple.

The entrance to Uluwatu Temple
high on the cliffs overlooking the sea.

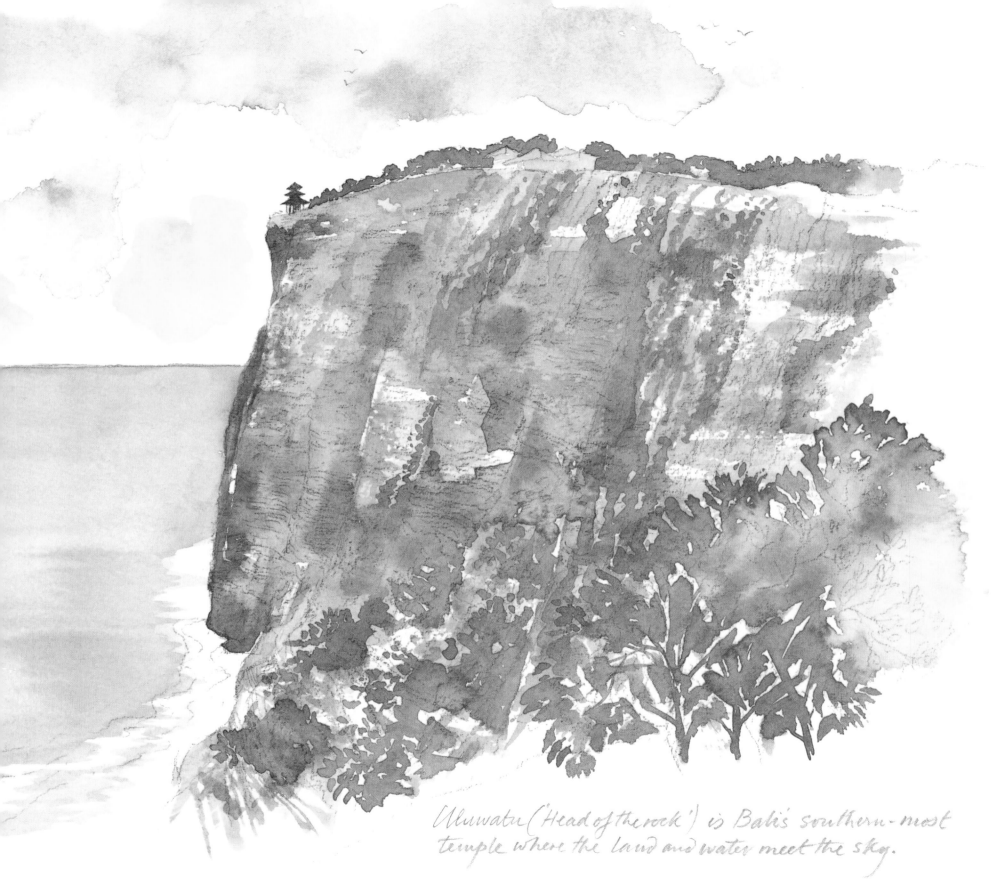

Uluwatu ('Head of the rock') is Bali's southern-most temple where the land and water meet the sky.

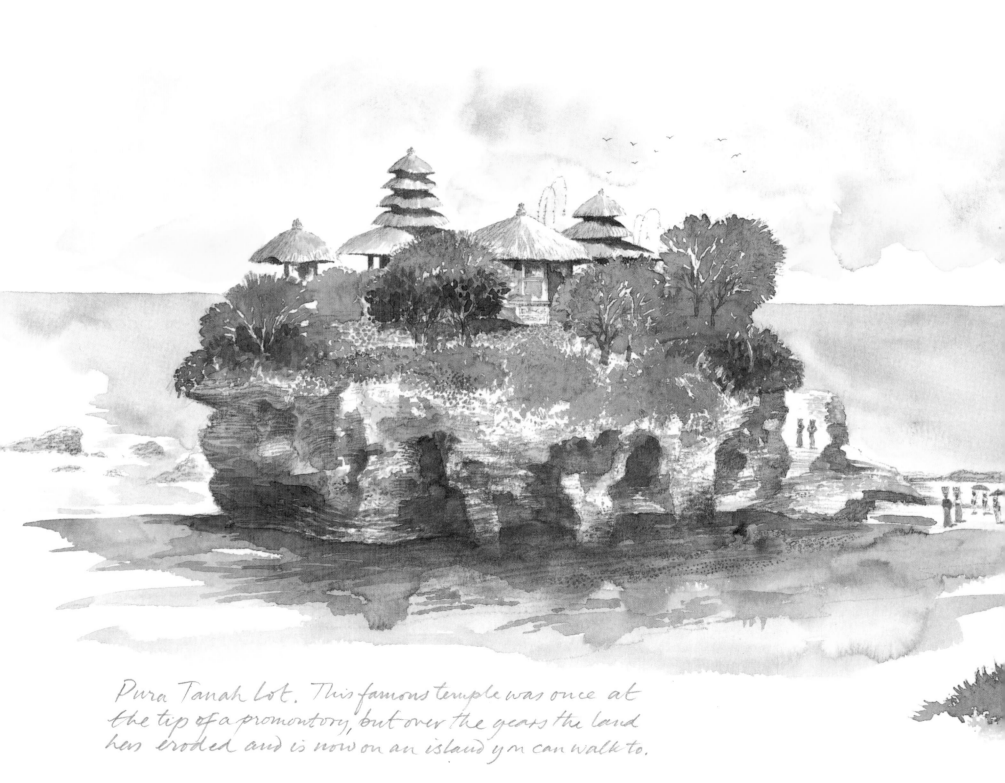

Pura Tanah Lot. This famous temple was once at
the tip of a promontory, but over the years the land
has eroded and is now on an island you can walk to.

Although this little temple island is a
famous tourist site, it remains sacred to
thousands of Balinese worshippers
who climb its steps with offerings.

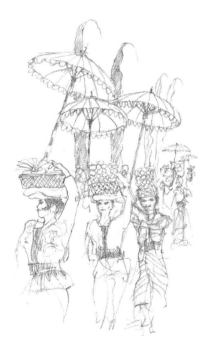

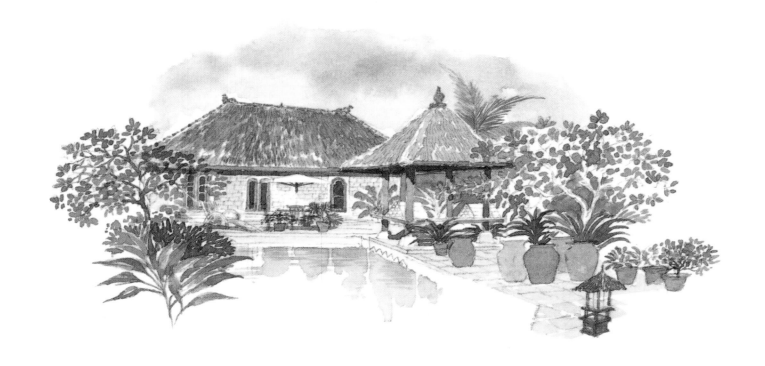

96 Bali Sketchbook